IMAGES
of America
PITTSBURGH'S BRIDGES

Index Map

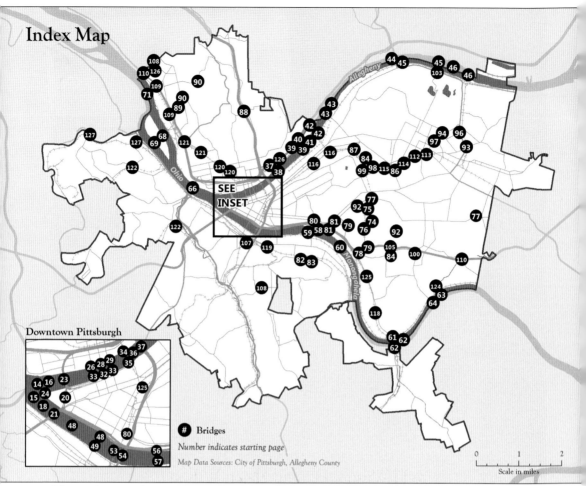

This index map locates starting page numbers for descriptions of bridges in this book. (Map created by Lauren Winkler, Michael Baker International.)

ON THE COVER: The photograph shows the Point of Pittsburgh as it appeared for just a few years around 1920. The new 1915 Manchester Bridge crosses the Allegheny River at upper left, and the old 1877 Point Bridge crosses the Monongahela River at lower right. The Point Bridge was closed in 1924 and replaced in 1927. (Carnegie Library of Pittsburgh.)

IMAGES of America
PITTSBURGH'S BRIDGES

Todd Wilson, PE, and Helen Wilson

Copyright © 2015 by Todd Wilson, PE, and Helen Wilson
ISBN 978-1-4671-3424-8

Published by Arcadia Publishing
Charleston, South Carolina

Printed in the United States of America

Library of Congress Control Number: 2015949613

For all general information, please contact Arcadia Publishing:
Telephone 843-853-2070
Fax 843-853-0044
E-mail sales@arcadiapublishing.com
For customer service and orders:
Toll-Free 1-888-313-2665

Visit us on the Internet at www.arcadiapublishing.com

This book is dedicated to my late father, Richard S. Wilson, who bought me my first camera when I was six so we could drive around the Pittsburgh area to photograph bridges. Year after year, he made time for our bridge trips, even when he was too busy. Instead of saying no, he would say, "It's a possibility." His relentless energy and determination taught me that it's a possibility if you refuse to quit.
—Todd Wilson

Contents

Acknowledgments		6
Introduction		7
1.	Point Bridges	11
2.	Allegheny River Bridges	25
3.	Monongahela River Bridges	47
4.	Ohio River Bridges	65
5.	Ravine Bridges	73
6.	City Beautiful Bridges	91
7.	Railroad Overpasses	111
8.	Footbridges	123

Acknowledgments

Writing a book is indeed a labor of love, and we are indebted to the outstanding people and organizations that made this book possible.

We wish to give special thanks to the Pittsburgh History & Landmarks Foundation, especially Arthur P. Ziegler Jr., president; Louise Sturgess, executive director; Matthew J. Ragan, preservation director; Albert M. Tannler, historical collections director; Frank Stroker, archivist; and Judith Harvey, librarian, Fairbanks Rail Transportation Archives.

We also wish to thank Dr. Steven Fenves, engineering professor emeritus, Carnegie Mellon University; Nathan Holth, HistoricBridges.org; Bruce Cridlebaugh, pghbridges.com; and David Wright, project manager, Allegheny County Department of Public Works, for reviewing the manuscript and providing photographs, articles, and other resources. We thank the civil engineering community, including John F. Graham, Benjamin Allis, Richard Krajcovic Jr., Stephen Walker, and the American Society of Civil Engineers (ASCE) Pittsburgh Section, especially Gregory Scott and Cathy Bazán-Arias for providing information, reviews, feedback, and encouragement.

We wish to recognize the Pittsburgh Department of Public Works Bureau of Transportation and Engineering, Mike Grable, director, and especially Mark Stem, project engineer, who was so enthusiastic in providing us with photographs and other documents; the Allegheny County Department of Public Works, Stephen G. Shanley, director; Gilbert Pietrzak, coordinator, Pittsburgh Photographic Library, housed at the Pennsylvania Department, Carnegie Library of Pittsburgh; Heather Nicholson, marketing communications manager, American Bridge Company; Jacqueline Fox, media relations manager, HDR Inc.; Matthew Strauss, chief archivist, Thomas and Katherine Detre Library and Archives, Senator John Heinz History Center; Archives Service Center/University of Pittsburgh; Dr. Elisabeth Roark, associate professor of art, Chatham University; Jenifer Monger, assistant institute archivist, Institute Archives and Special Collections, Folsom Library, Roebling Collection, MC4, Rensselaer Polytechnic Institute, Troy, New York; Michael Ehrmann, president, Squirrel Hill Historical Society; John W. Eichleay Jr., Eichleay Corporation Archives; Library of Congress Prints and Photographs Division, HAER Collection, Washington, DC; and companies that digitize historical maps and images, such as Google and the Internet Archive.

We wish to thank Lauren Winkler, GIS specialist, Michael Baker International, for creating the index map.

We wish to recognize professors and staff at Carnegie Mellon University, especially Dr. David Dzombak, P.E. and Mireille Mobley of the Department of Civil and Environmental Engineering, and Dr. Joel A. Tarr and Jesse Wilson of the Department of History for providing research support and photographs.

We wish to thank Arcadia Publishing, especially Stacia Bannerman and Abby Henry.

All photographs without attribution are from the Wilson family collection.

INTRODUCTION

Perhaps no other city in the United States is as well known for its collection of bridges as Pittsburgh, Pennsylvania. While some cities have a signature bridge—the Brooklyn Bridge in New York City and the Golden Gate Bridge in San Francisco come to mind—Pittsburgh has so many notable bridges that it is not defined by a single bridge but by its diverse collection, earning it the title "City of Bridges." Pittsburgh's wealth of bridges is due to its topography. The city is located on a deeply eroded plateau cut by wide rivers and small streams, without much level ground. The city's neighborhoods are located along the rivers and in the hills and valleys, connected by many different bridges.

Pittsburgh is situated where the south-flowing Allegheny River and north-flowing Monongahela River meet to form the Ohio River, the largest river connecting the Appalachian region to the Mississippi River. Its location has always been strategic. In the 1700s, the land at the "Forks of the Ohio," as it was then called, was contested by the French, British, and Native Americans. The British gained full control of the Point in 1758 and built Fort Pitt, one of their largest in the colonies. A small settlement developed around the fort, named Pittsburgh by Gen. John Forbes. It became a township in 1771, a borough in 1794, and a city in 1816. Pittsburgh became known as the "Gateway to the West" because travelers stopped here to gather supplies and equipment for their journey westward along the Ohio River. From the beginning of Pittsburgh's history, its rivers were conduits for transportation of people and goods.

In the early 1800s, Pittsburgh was not the only city vying to be the Gateway to the West. To the south, the National Road (Route 40) was completed in 1818 from the Potomac River at Cumberland, Maryland, to Wheeling, Virginia (now West Virginia). It was the first federally funded road into the western frontier, but it bypassed Pittsburgh. A few years later, in 1825, the Erie Canal opened in New York, connecting Albany to Buffalo, promoting trade along the Lake Erie shores to the north. Pittsburgh found itself losing out to Buffalo, Cleveland, Louisville, Wheeling, and Cincinnati. The city's role as a transportation hub began to diminish.

In response to the challenge presented by the Erie Canal, the Pennsylvania legislature passed a series of acts from 1824 to 1826 authorizing a canal to be built at state expense to connect Pittsburgh and Philadelphia. The Main Line of Public Works, commonly called the Pennsylvania Canal, became fully operational in 1834. It entered downtown Pittsburgh by means of a wooden aqueduct across the Allegheny River, constructed in 1829 near where the Fort Wayne Railroad Bridge is now. The difficulties and cost of building and maintaining the canal made it unprofitable. It was obsolete almost from the start, as modern locomotive travel began in America in the late 1820s. In 1846, just 12 years after the canal's completion, the Central Railroad, later the Pennsylvania Railroad, was chartered to connect Pittsburgh and Philadelphia. It began operations in Pittsburgh in 1852 and was completed to Philadelphia in 1854, forcing the canal out of business. The railroad purchased the canal in 1857 and used some of its right-of-way to improve its alignments and widen its tracks. In 1861, the Western Pennsylvania Railroad purchased the abandoned canal right-of-way along the Allegheny River for its line.

Railroads led to advancements in bridge design and construction. Locomotives and trains were longer and heavier than any previous methods of transportation, so they required nearly level ground. In hilly terrain, viaducts were needed to cross over valleys. Before railroads, most bridges

were constructed from local materials such as wood and stone. Railroads needed materials stronger and more durable than wood and more versatile and cheaper than masonry. Advances in design and construction helped bridge-building in America develop from a craft to a science.

The growth and development of railroads corresponded with the improvement of commercial navigation on the rivers through the construction of locks and dams in the 1800s, which permitted slack-water navigation. Southwestern Pennsylvania was rich in coal, natural gas, and oil, allowing Pittsburgh to establish itself as a manufacturing hub. Railroads provided additional routes for shipping and receiving goods. Areas with both river and rail access became ideal for large-scale manufacturing.

Meanwhile, Pittsburgh's hilly topography and wide rivers made transportation difficult. No bridges spanned Pittsburgh's rivers when it was incorporated as a city in 1816, but that soon changed. Pittsburgh's first river bridge was built over the Monongahela River in 1818, and the second was erected over the Allegheny River in 1819. Those bridges were privately owned. In the early 1800s, government funding was limited to investing in companies that needed to raise capital to build bridges. Pennsylvania owned approximately a third of the stock for the companies that built Pittsburgh's first two bridges. State involvement diminished in the 1840s, but private toll bridges continued to be built. The tolls paid the debt incurred by the private companies that financed, designed, and constructed the bridges and also provided the means for maintaining them.

As small municipalities along the rivers were annexed by Pittsburgh in the 1800s and early 1900s, city residents became increasingly frustrated by bridge tolls within the city. The unpopularity of the tolls led the city and Allegheny County to begin purchasing privately owned bridges and removing tolls starting in 1896 and ending in 1926, when the Hays-Glenwood Bridge was purchased. Pittsburgh's first government-funded toll-free bridge, the Brady Street Bridge across the Monongahela River, opened in 1896.

As Pittsburgh's territory expanded, it outgrew its governmental system of having standing committees for different purposes, which made coordinating, implementing, and financing public works difficult. In 1887, city government was reorganized and modernized. A set of executive departments was created, one of which was the Department of Public Works. It contained a number of bureaus, including Bridges and Engineering. Its first director was Edward M. Bigelow, whose visionary leadership and engineering background provided Pittsburgh not only with its beautiful city parks but also with many new roads and bridges.

The development of streetcar systems in Pittsburgh starting in the 1850s opened up new areas of the city for development. Various forms of streetcars were invented, first horse-drawn, then cable-pulled, and finally electric powered. Especially after 1886, when electric trolley lines began to be built throughout Pittsburgh, these light-rail lines became conduits for Pittsburgh's growth, enabling commuters to travel longer distances to work. Electric streetcars were heavier than the horse-drawn vehicles they replaced, requiring stronger bridges connecting city neighborhoods.

The proliferation of the automobile in the early 1900s was the impetus for even more street and bridge construction. Houses could now be built anywhere, as long as they were connected to a suitable street. At first, streets were haphazard, cut wherever the terrain would allow, but in 1909, a city planning report concluded that lack of improved roads could inhibit Pittsburgh's growth. Renowned landscape architect and urban planner Frederick Law Olmsted Jr. was commissioned to study the issue. His 1910 report recommended that higher-capacity automobile roads, or thoroughfares, be built to efficiently connect downtown with city neighborhoods and suburbs. The City Planning Department and the Municipal Art Commission were created in 1911 to work with the Public Works Department to implement Olmsted's plan. The planning department determined where the roads and bridges should go, the public works department figured out how to build them, and the art commission decided what they should look like.

As Pittsburgh industrialized in the 1800s, the pace of progress superseded other concerns. Companies were more focused on producing glass, iron, steel, and other products than with the city's appearance. As Pittsburgh leaders became wealthy enough to reflect upon their success, they found dirt, grime, and smoke enshrouding warehouses and factories. John Beatty, Carnegie

Institute's director of fine arts, began to advocate for an art commission around 1907, about the same time Pittsburgh annexed Allegheny City (now North Side). The World's Columbian Exposition in Chicago in 1893 provided a vision of what a city could be—pleasing to the eye, with classical architecture, sweeping boulevards, and landscaped parks. Beatty felt it was time for Pittsburgh to have an art commission as a way to implement such a vision through beautifying civic structures, including bridges.

Initially, the art commission concerned itself only with artistic embellishments on bridges, having no real power except to veto designs it felt were not aesthetically pleasing. However, when the US War Department mandated that nine Allegheny River bridges needed to be replaced to improve river navigation, the commission vetoed designs that did not consider structural form as part of the bridge's artistic merit. This included maintaining views of the city from the bridge decks, likely a reaction to the cagelike roadways of some of Pittsburgh's earlier bridges.

Pittsburgh's annexation of Allegheny City was so complicated and controversial that only a few other municipalities were incorporated into Pittsburgh afterwards. Meanwhile, automobiles were proliferating, and more and more workers were moving to the suburbs. As regional road infrastructure increasingly became a county issue, the Allegheny County Road Department, created in 1895, needed to expand. In 1913, the county was authorized to improve the roads within municipalities that provided access to county roads. Pittsburgh mayor Joseph Armstrong (1914–1918), who had been public works director under Mayor Magee, believed the city and county could grow and prosper only with adequate infrastructure serving the new automobile age. Armstrong successfully ran for Allegheny County commissioner in 1923 and created the county's Department of Public Works (DPW) in 1924. He championed bond issues to modernize and expand the county's infrastructure, including bridges, which passed by a greater than two-to-one margin.

Breaking from the typical practice of hiring outside consultants, the county DPW was a well-funded organization with a large staff of engineers able to do design work in-house. Key DPW figures included its director, Norman Brown; chief engineer Vernon Covell, and, later, George Richardson; and architect Stanley Roush. All of these men worked closely with the art commission. From 1924 to 1932, ninety-nine bridges were constructed at a cost of $47 million, causing the DPW to consume over 50 percent of the county's yearly revenue. Weakened by allegations of corruption and overspending, Armstrong was defeated at the polls in 1931, and the DPW was downsized.

When Franklin D. Roosevelt became president in 1933, he authorized federal funding for public-works projects during the Great Depression through his New Deal programs, allowing the DPW to grow again. This funding allowed Allegheny County to design major bridges, such as the 1937 Homestead High Level (Homestead Grays) Bridge, until such projects came to a halt with the onset of World War II.

The Pennsylvania Highway Department was created in 1903, and the first state highways were designated in 1911. As the Pittsburgh metropolitan area developed beyond its county boundaries, major road and bridge construction increasingly became the state's responsibility. Construction of the Penn-Lincoln Parkway (I-376) began in 1946, was completed in 1964, and included several noteworthy bridges. The highway department was expanded to become the Pennsylvania Department of Transportation (PennDOT) in 1970. The state took over ownership of many of the busiest city- and county-built bridges by Act 615 of 1961.

A number of engineers were instrumental in the history of bridge building in Pittsburgh. John Augustus Roebling (1806–1869), best known for the Brooklyn Bridge in New York City, began his bridge engineering career in Pittsburgh by replacing the first Allegheny River aqueduct for the Pennsylvania Canal with an innovative suspension bridge made possible by the wire-rope cable system he developed. Roebling subsequently designed two other suspension bridges to replace Pittsburgh's first two bridges—the 1818 Monongahela River Bridge at Smithfield Street and the 1819 Allegheny River Bridge at Sixth Street.

Gustav Lindenthal (1850–1935) was another important engineer who became famous for his work in Pittsburgh. He designed the third Smithfield Street Bridge in 1881–1883, which still

stands, and the Allegheny River bridges at Seventh and Thirtieth Streets. Lindenthal, like Roebling, went on to become a noted bridge engineer, designing such monumental bridges as the Hell Gate Bridge in New York. Allegheny County's 1931 McKees Rocks Bridge pays homage to the Hell Gate Bridge's design.

George S. Richardson (1896–1988) was Pittsburgh's most prominent bridge engineer in the 1900s. He began his career with the Allegheny County DPW in the 1920s. Rising to chief engineer, Richardson worked on many of Pittsburgh's noteworthy bridges. After he left the department, he founded a private consulting practice, Richardson, Gordon and Associates, now part of HDR Inc. The firm designed many of Pittsburgh's newer highway bridges for the state and county.

This introduction would not be complete without a description of what a bridge is and how it functions. A bridge is defined as "a structure that carries a load over open space." Bridges are classified by the way they are designed to support loads. Some bridges work by compression, in which structural members are pushed together, creating an arc that curves downward, called an arch, found in arch bridges. Other bridges work by tension, in which structural members are pulled apart, creating an arc that curves upward, called a catenary, found in suspension bridges. Compression and tension are opposite forces, so arches and catenaries curve in opposite directions. The longer the curve, the longer the distance the bridge can span.

Bridges that support loads by withstanding bending are called beam bridges. A beam that is supported at each end will sag downward under a load, causing its top surface to be pushed inward (compression) and its bottom surface to stretch outward (tension). A beam that has an end extending beyond a support will sag downward, reversing the tensile and compressive forces. Beam bridges are classified into simple, continuous, and cantilever structures depending on how the beams are arranged on their supports. Bridges with beams that start at one support and end at the next support are simple structures. Bridges with beams that continue across intermediate supports are continuous structures. Bridges with beams that project outward beyond their supports are cantilevered structures, which have longer center spans and shorter side spans, particularly useful for bridges needing longer spans over rivers and valleys.

Beams are typically solid, built from steel or concrete. The longer the length the beam needs to span, the thicker the beam needs to be. Especially in the 1800s and early 1900s, before stronger modern materials were developed (iron started to be used regionally in the 1830s and steel in the 1870s), the solution to creating thicker beam structures was to develop a truss—triangular shapes connected together. Various methods of putting trusses together to form beamlike structures were patented and named after their inventors. Pratt trusses were the simplest—trapezoidal shapes with right triangles, with vertical members in compression and diagonal members in tension. As Pratt trusses became longer, they were subdivided (Baltimore), doubled (double-intersection Pratt, or Whipple), curved upward to be thicker at midspan (Parker), curved upward and subdivided (Pennsylvania), or curved upward and downward (lenticular). Trusses were built with isosceles triangles (Warren), in which some diagonals operate in compression and others in tension. Howe trusses had vertical members in tension and diagonal members in compression.

Bridges can also be classified based on where the support structure is located in relation to the deck. When the support structure is above the road deck, it is a through bridge. When the support structure is alongside but not above the road deck, it is a pony bridge. When the support structure is below the road deck, it is a deck bridge.

Each chapter of this book deals with a different aspect of Pittsburgh's bridge-building history. Chapter one discusses the skyline-defining bridges at Pittsburgh's Point. Chapters two, three, and four are histories of the bridges within the city limits over the Allegheny, Monongahela, and Ohio Rivers, respectively, moving outward from the Point. Chapters five, six, and seven describe Pittsburgh's bridges over valleys, ravines, and railroads. Chapter eight highlights Pittsburgh's unique pedestrian-only footbridges.

One
POINT BRIDGES

Throughout history, places where rivers met often became strategic locations. In the 1700s, the French, Native Americans, and British fought for control of the land at the "Forks of the Ohio," where the Allegheny and Monongahela Rivers join to form the Ohio River. Ownership of the forks was critical to controlling westward expansion. The French built Fort Duquesne there in 1754, but the British captured it and constructed Fort Pitt in 1758. The settlement that grew around the fort became Pittsburgh.

When Pittsburgh was incorporated as a city in 1816, it had no river bridges, but this soon changed. The city's first bridges were built over the Monongahela River at Smithfield Street in 1818 and over the Allegheny River at Sixth Street in 1819. By 1870, bridges at eight other locations had been constructed within the city's present-day boundaries. All were to the east, upriver from the Point. The Point was not a great location for bridges—the ground, low and swampy, often flooded.

The first bridge at the Point, authorized in 1846, was proposed to be a Y-shaped structure connecting the Point with both shores of the Ohio River. It failed to attract sufficient investment, and merchants feared the bridge would be an obstruction to river traffic. After a proposal for a similar bridge failed in 1871, two toll bridges were constructed over the Allegheny and Monongahela Rivers from 1875 to 1877, intersecting at the Point. These bridges greatly improved access to western communities and provided an Ohio River crossing, albeit indirect, that bypassed downtown.

Since Pittsburgh began at the Point, the bridges there became more than just functional crossings—they became part of the city's skyline and character. The progression of bridges at the Point illustrates how the city's bridges evolved from being merely utilitarian structures to edifices thoughtfully designed to symbolize a city's vision—in the case of Pittsburgh, the "Golden Triangle."

This chapter tells the story of how the bridges at the Point changed over time through the efforts of engineers, architects, urban planners, public officials, business leaders, and involved citizens.

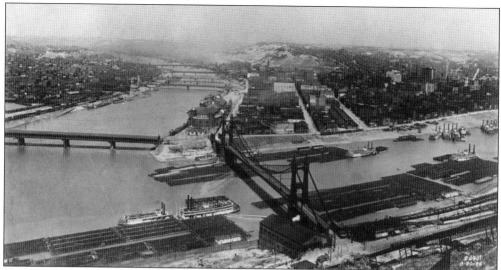

This 1896 photograph shows the first generation of bridges at the Point. The 1875 Union Bridge (left) crosses the Allegheny River. The 1877 Point Bridge (center) crosses the Monongahela. The Duquesne Heights Incline can be seen at lower right. It was located to connect the bridge with the top of Coal Hill (Mount Washington) and was completed one month after the bridge. (Carnegie Library of Pittsburgh.)

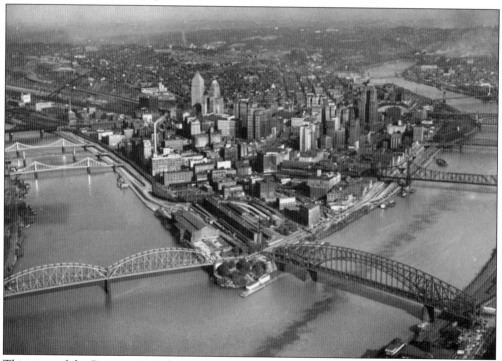

This view of the Point in 1947 shows the second generation of bridges. The previous ones were replaced with the 1915 Manchester Bridge (left) over the Allegheny River and the 1927 Point Bridge (right) over the Monongahela River. The photograph shows the booming postwar city a few years before the Renaissance I urban renewal projects led to drastic changes. Only a small park existed at the Point. (Carnegie Library of Pittsburgh.)

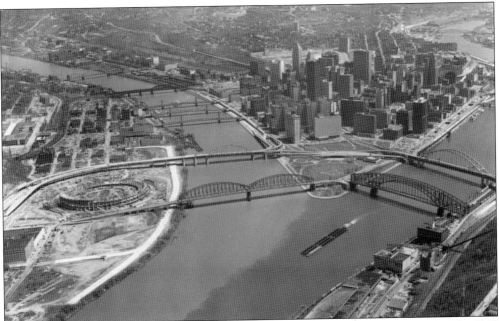

The transition from the second to the third generation of bridges is seen here in 1969. The 1963 Fort Duquesne Bridge (just above center) is upriver from the Manchester Bridge, and the 1959 Fort Pitt Bridge (far right) is upriver from the Point Bridge. The photograph shows most of the Renaissance I projects completed or under construction, including Three Rivers Stadium (left). (Carnegie Library of Pittsburgh.)

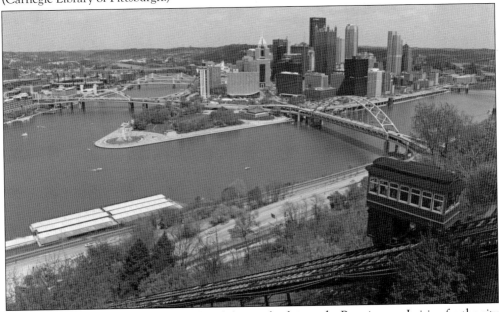

This 2015 photograph shows how Pittsburgh has evolved since the Renaissance I vision for the city was completed in the 1970s, with the Point Park fountain as its focal point. The third-generation Point bridges delineate the Golden Triangle. While much has changed, the 1877 Duquesne Incline (lower right), which once connected the original Point Bridge to Mount Washington, remains in operation.

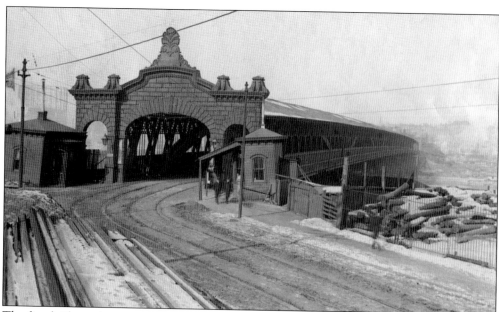

The first bridge to be constructed at the Point was the Union Bridge over the Allegheny River. It connected Allegheny City (now Pittsburgh's North Side) with the tip of the Point. The 1875 bridge was the last wooden covered river bridge built in Pittsburgh. It had grand Italianate neo-Renaissance portals with simulated stonework. (Carnegie Library of Pittsburgh.)

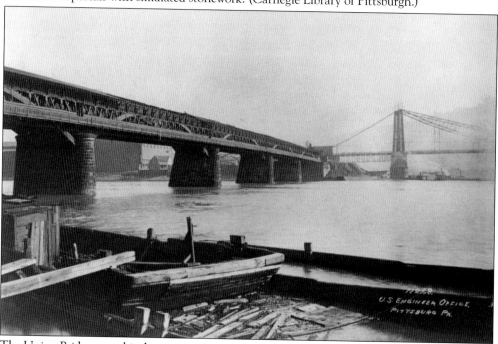

The Union Bridge was a hindrance to navigation on the Allegheny River, as its clearance dropped to as little as seven feet when the water was high. A petition to the US secretary of war in 1902 resulted in the bridge being declared an obstruction to navigation. On appeal, the Supreme Court ruled the bridge had to be raised or razed. The bridge was demolished in 1907. (Carnegie Library of Pittsburgh.)

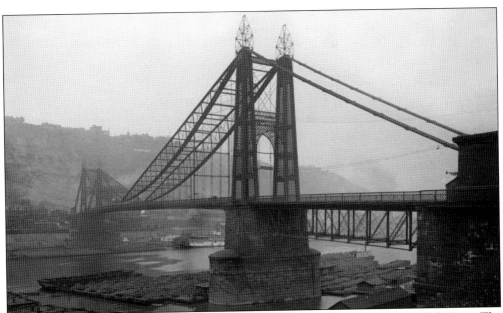

The Point Bridge Company was chartered in December 1874 to span the Monongahela River. The company faced the challenge of satisfying navigational interests that controlled the Monongahela while designing an economical bridge. The resulting suspension bridge had an 800-foot main span and a vertical clearance of up to 83 feet above low water. Land at the Point had to be raised to form the bridge approach. (Library of Congress.)

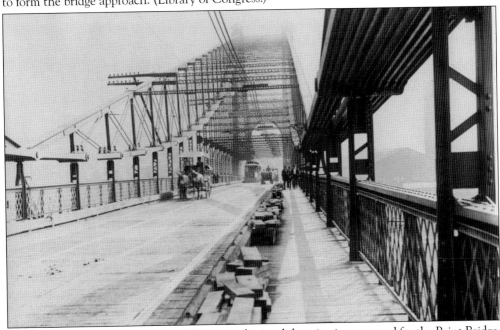

The American Bridge Company of Chicago submitted the winning proposal for the Point Bridge. Suspension bridge decks are usually stiffened to provide rigidity, which is costly. The Point Bridge had a novel design in which the catenaries were stiffened by trusses, allowing the bridge to be built for half the cost of comparable bridges. Pittsburgh Locomotive Works in Allegheny City (North Side) manufactured the eyebars. (Carnegie Library of Pittsburgh.)

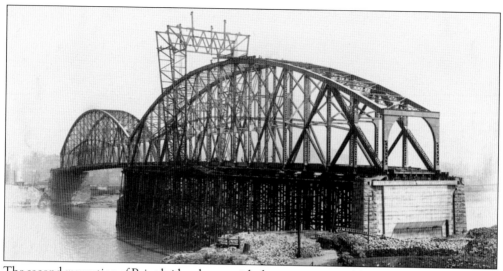

The second generation of Point bridges began with the construction of the Manchester Bridge from 1911 to 1915 over the Allegheny River. This replaced the Union Bridge, which was demolished in 1907. The American Bridge Company constructed the northern span first, then the southern span, which is shown here under construction in July 1913. The two spans were constructed at different times in order to keep the river channel open for navigation. (Pittsburgh Department of Public Works.)

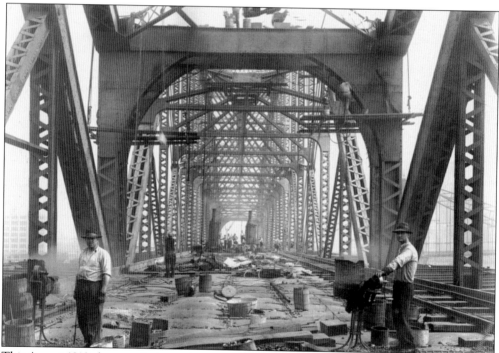

This August 1913 photograph shows riveting in progress on the Manchester Bridge. Steel members were fastened together using metal pins, called rivets. The rivets were heated in portable forges (foreground) or larger furnaces (background) along the bridge deck until they were red hot. Workers at the forges tossed the hot rivets up to the men on the scaffolding, who hammered them into place. (Pittsburgh Department of Public Works.)

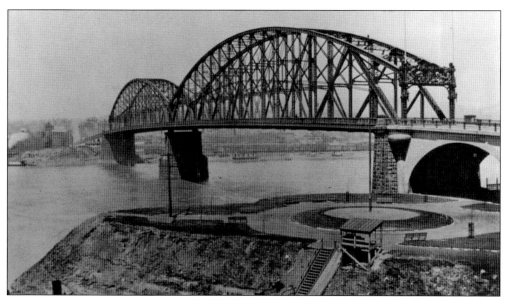

The Manchester Bridge opened to traffic on August 8, 1915. It featured two 531-foot Pennsylvania truss spans, among the longest in America, and eight concrete arch approach spans. The original plan called for stone portals to be built at each end of the trusses, so the trusses were extended to end vertically at the portals. The stone portals were never built. (American Bridge Company.)

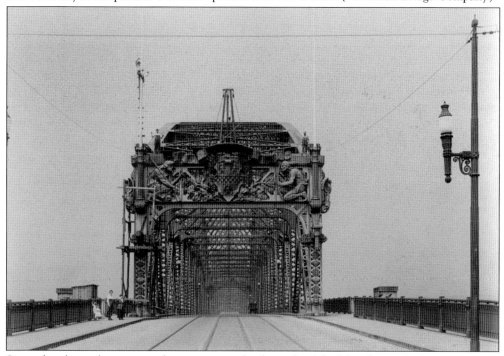

Since the planned stone portals were too costly, the ends of the Manchester Bridge trusses were unadorned when the bridge opened in 1915. Metal sculptures were added to the steel portals instead. The Pittsburgh side (pictured) depicted pioneer scout Christopher Gist, Pittsburgh's coat of arms, and Chief Guyasuta. The north side depicted a millworker and a coal miner. Here, men paint the new flagpoles in 1918. (Pittsburgh Department of Public Works.)

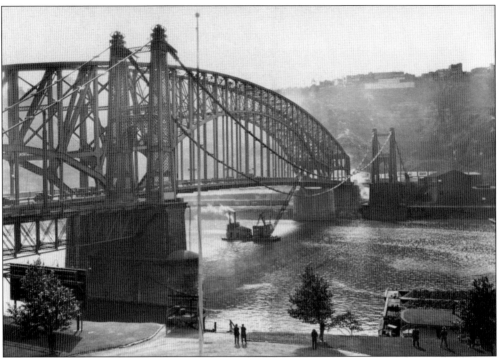

In 1924, the first Point Bridge over the Monongahela River was closed to traffic due to deterioration. After much public pressure, the bridge was replaced by a larger structure, completed in 1927. The old bridge was demolished. This October 1927 photograph shows the demolition of the first Point Bridge's main catenaries, the last part of the river span to go. (Pittsburgh Department of Public Works.)

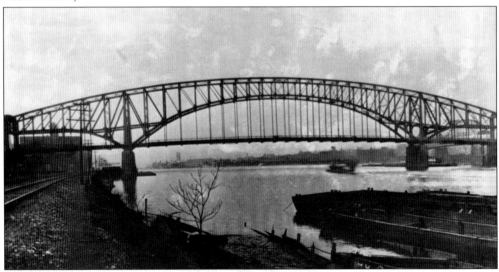

Designing the new Point Bridge was a formidable task. Chief engineer George Richardson and architect Stanley Roush had to win approval from the Municipal Art Commission, formed in 1911, which mandated a design complementary to the Manchester Bridge to create a more unified appearance at the Point. The bridge needed a long span over the river, and its approaches had to tie into existing infrastructure. (Allegheny County Department of Public Works.)

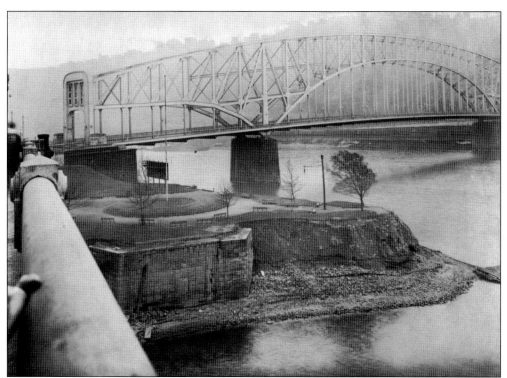

Engineers and architects devised a unique cantilever truss design for the Point Bridge, in which the road deck hung below the trusses. This allowed the long span over the river to have the gently curved top mandated by the city's art commission. The architectural journal of the time, the *Charette*, compared the design to the Pitt Panther. A small park was eventually created at the Point. (Pittsburgh Department of Public Works.)

Monumental steel portals were installed at both ends of the new Point Bridge. Since the bridge was a balanced cantilever, the portals did not serve a structural purpose. The bridge was closed in 1959, the year after this photograph was taken. It was demolished in 1970 as part of the Renaissance I urban renewal project that included the creation of Point State Park. (Dr. Steven Fenves collection.)

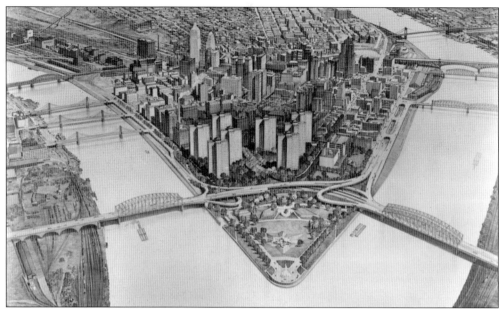

Throughout the 1950s, various designs were explored to redevelop Pittsburgh's Point into a park. Improving traffic flow was an important consideration. Since the existing bridges were too close together to permit an interchange, new bridges farther from the Point were needed. This concept from around 1950 shows single-level Point bridges constructed in the style of the Manchester Bridge, with long center spans over the rivers. (Carnegie Library of Pittsburgh.)

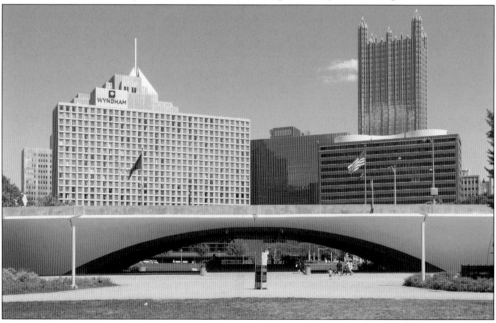

Planners were concerned that the highway between the new Point bridges would form a barrier to the new Point State Park. Architecture and engineering were combined to form an inviting entryway for drawing people into the park. The 1963 Portal Bridge was designed as a long, flat arch less than three feet thick above its crown to maximize its opening. It was a pioneer of prestressed concrete technology.

Another issue for the new Point bridges was avoiding large, looping ramps that would intrude into the new Point State Park. Chief engineer George Richardson and engineer Mike Rapuano devised a plan of double-deck bridges that would eliminate flyover ramps. The truss bridge designs were revised to be tied-arch bridges. The double-deck Fort Pitt Bridge is shown here under construction in 1958. (Carnegie Library of Pittsburgh.)

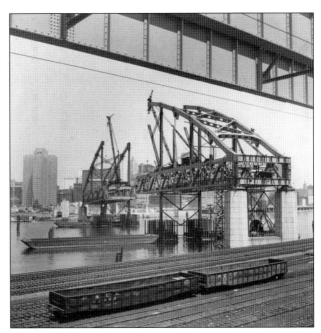

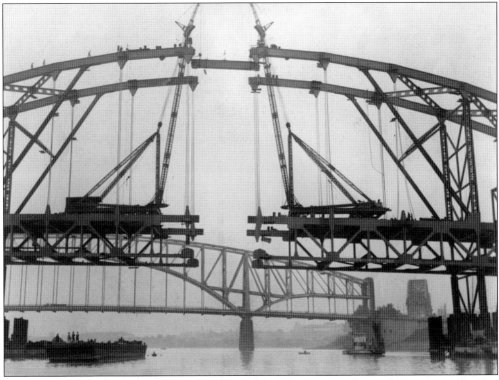

It was a momentous occasion in 1958 when the final beams were hoisted to connect the Fort Pitt Bridge's arch. The bridge is a tied arch, so the lower trusses act as tension members tying the ends of the arches together, countering their outward thrust. After the arches were connected, the lower trusses were completed, making the bridge self-supporting and enabling the removal of temporary support towers. (Carnegie Library of Pittsburgh.)

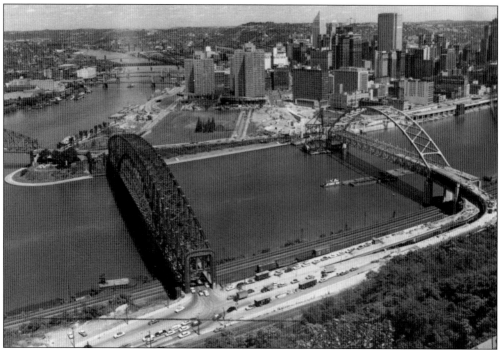

In 1958, the Fort Pitt Bridge (right) was taking shape next to the Point Bridge. George Richardson was chief engineer of both bridges, each of which was designed to beautify the Point area and provide a gateway to the city. The Point can be seen cleared for construction of Point State Park. Left standing is the Fort Pitt blockhouse, which became a museum. (Carnegie Library of Pittsburgh.)

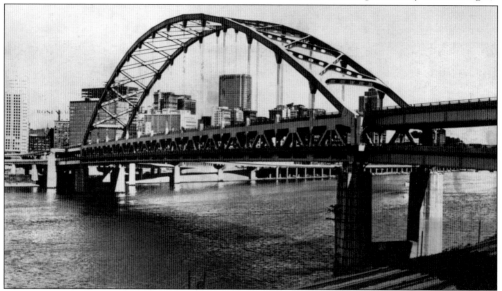

The innovative Fort Pitt Bridge opened to traffic on June 19, 1959. It was the first double-decked tied-arch bridge and one of the earliest bridges designed with the assistance of computers for the performance of calculations. Upon its opening, Gov. David Lawrence noted, "As significant as it is a means of attacking the traffic problem, the bridge has a special importance as a testimonial to the rejuvenation of the City." (HDR Inc.)

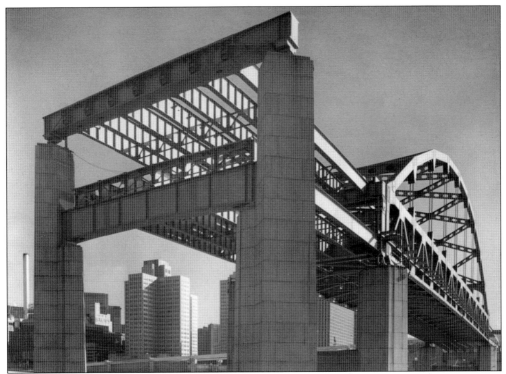

Construction on the Fort Duquesne Bridge began in 1958. Its arch and downtown-side ramps were mostly completed when this photograph was taken in 1962. The bridge became the "Bridge to Nowhere" in the 1960s until the first of its North Side approaches was completed in 1969. The other was completed in 1986, and the envisioned highway connections were completed in 1991. (Carnegie Library of Pittsburgh.)

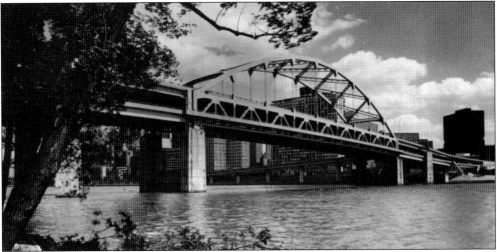

After over 40 years of planning, the Renaissance I vision for the Point was fulfilled with the completion of the Fort Duquesne Bridge in 1969 and Point State Park in 1974. Perhaps the Fort Duquesne Bridge could have been more economically designed, but it was built to match the Fort Pitt Bridge. The Point became part of Pittsburgh's identity, a public space uniting engineering, urban planning, landscape architecture, and art. (HDR Inc.)

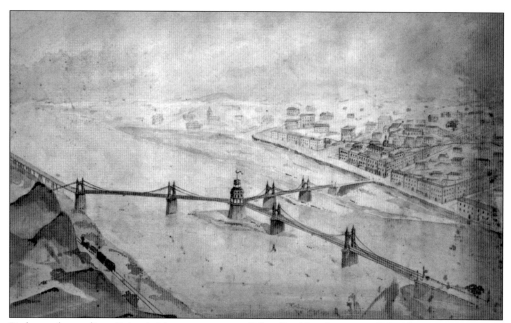

Perhaps the earliest Point bridge concept was John Roebling's proposal for the 1846 Tripartite Bridge, a Y-shaped suspension bridge with spans connecting the banks of Pittsburgh's three rivers. It failed to attract investors, who were concerned about costs and potential obstructions of river traffic. The concept was unsuccessfully revived in 1871 by Washington Roebling. It likely provided inspiration for the separate bridges built at the Point in 1875–1877. (Heinz History Center.)

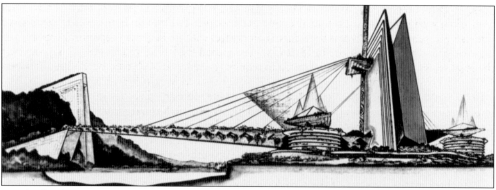

Frank Lloyd Wright also designed conceptual Point bridges that were never built. Department-store owner and Allegheny Conference board member Edgar Kaufmann commissioned Wright to design a civic center at the Point. Wright's second design, from 1948 (pictured), included prestressed concrete cable-stayed bridges over the Monongahela and Allegheny Rivers, connected by a 1,000-foot tower at the Point. The concept, ahead of its time, was too costly. (Carnegie Library of Pittsburgh.)

Two

ALLEGHENY RIVER BRIDGES

The 325-mile Allegheny River is the longest and largest of the Ohio River's tributaries. It follows a winding path from north-central Pennsylvania into New York, flowing southwest to meet the Monongahela River at the Point in Pittsburgh, where the rivers join to form the Ohio River. The Allegheny River contributes approximately twice as much water per day as the Monongahela River, but it did not develop into the industrial workhorse that the Monongahela did, due to its swifter current and its more numerous bridge obstructions.

The first river bridge in Pittsburgh was built across the Monongahela River in 1818, and the second across the Allegheny River in 1819. Because the Allegheny River separated Allegheny City (now Pittsburgh's North Side) and downtown Pittsburgh, more bridges were built across it than across the Monongahela River.

In the 1800s, bridges were financed by private companies, which built them as economically as possible. Before regulations mandated otherwise, the Allegheny bridges were built low over the river, often with many piers. This made commercial navigation difficult. In subsequent years, river interests pressured bridge owners to replace their bridges with higher, longer-spanning crossings to improve commercial navigation. In 1899, Congress passed the Rivers and Harbors Act, providing the legal basis for the US War Department to require the removal of obstructive bridges. Between 1907 and 1928, all of Pittsburgh's Allegheny River bridges were modified or replaced.

In the early 1900s, John Beatty, the Carnegie Institute's fine arts director, advocated for artistic improvement of Pittsburgh's public property. This led to the formation of the Municipal Art Commission in 1911. The commission insisted that bridges be beautiful as well as functional. County engineers Vernon Covell and Norman Brown and Allegheny County architect Stanley L. Roush worked closely with the commission to come up with innovative solutions for aesthetically pleasing bridges.

This chapter tells the story of the transformation of the utilitarian and obstructive Allegheny River bridges into an unprecedented collection of architecturally significant bridges through the influence of the Municipal Art Commission.

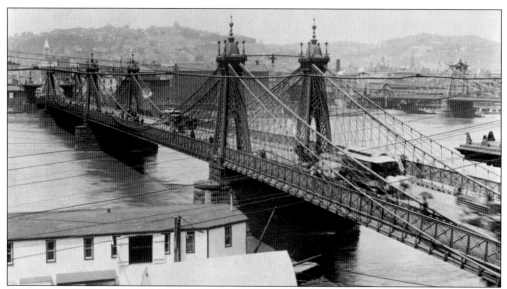

Pittsburgh's first bridge over the Allegheny River was Lewis Wernwag's 1819 covered bridge at St. Clair (Sixth) Street, owned by the Allegheny River Bridge Company. It was replaced by John Roebling's 1859 suspension bridge (pictured), which had two main spans, each 344 feet long. The bridge company's director, John Harper, believed that replacing the aging bridge with an attractive Roebling bridge would be appealing and therefore increase revenue. He was right. (Carnegie Library of Pittsburgh.)

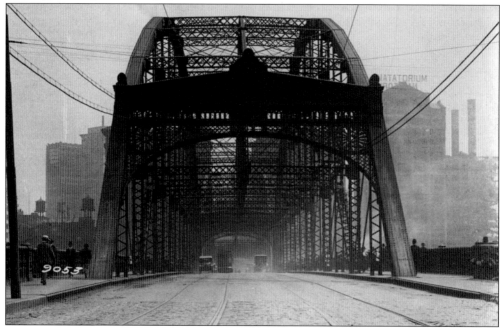

By the 1890s, Roebling's Sixth Street Bridge was unable to safely carry the heavier electric streetcars. The Allegheny River Bridge Company held a design competition to replace the Roebling bridge. Primary criteria were aesthetics and strength. An inverted-arch design was initially chosen, but it was later changed to a two-span Pennsylvania truss. Famed engineer Theodore Cooper designed the new bridge, fabricated by the Union Bridge Company. (Carnegie Library of Pittsburgh.)

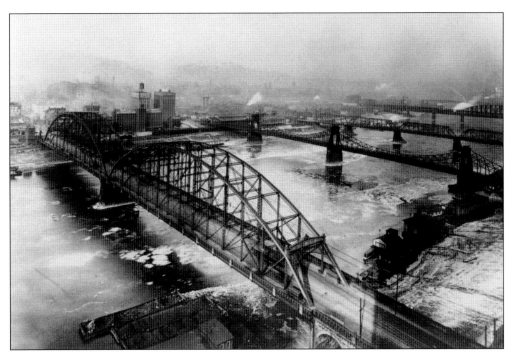

Theodore Cooper's truss bridge at Sixth Street (foreground) was completed in 1893. It was built around Roebling's suspension bridge, which remained open during construction and then was demolished. The truss bridge, constructed in 95 days, featured ornate portals produced by Jackson Architectural Iron Works of New York. The three bridges seen here in the foreground around 1910 were replaced in the 1920s with today's "Three Sisters." (Carnegie Library of Pittsburgh.)

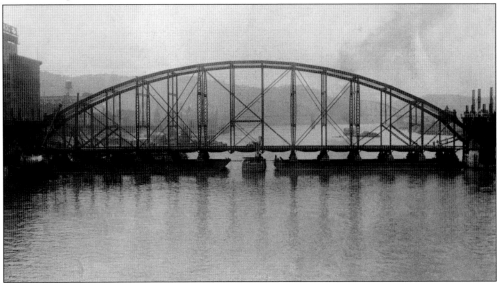

In 1917, the US secretary of war mandated the replacement of low Allegheny River bridges, including the 1893 Sixth Street Bridge. Since a bridge was needed on the Ohio River to connect Neville Island and Coraopolis, the Sixth Street Bridge was moved there in 1927. This photograph from that year shows the southern span being lowered onto barges, to be floated to Coraopolis for reerection. The bridge lasted there until 1994. (Carnegie Library of Pittsburgh.)

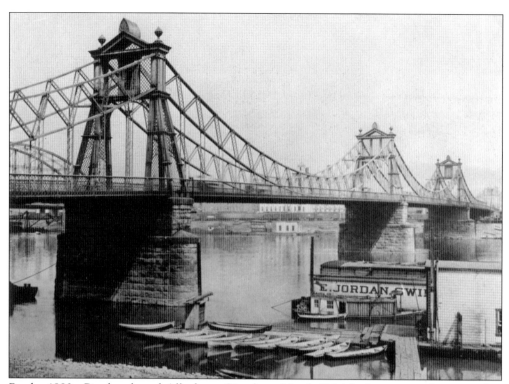

By the 1880s, Pittsburgh and Allegheny City (now North Side) had grown to the point that investors felt there would be enough traffic for a crossing at Seventh Street to compete with the bridges at Sixth Street and Ninth Street. The North Side Bridge Company hired Gustav Lindenthal, who was working on the 1883 Smithfield Street Bridge, to design the 1884 suspension bridge (pictured). (Carnegie Library of Pittsburgh.)

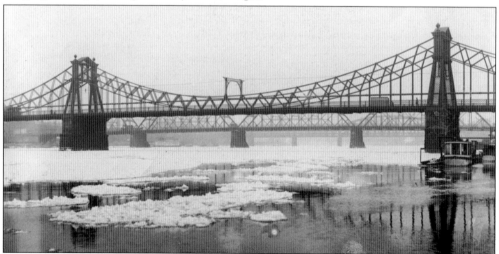

Lindenthal referred to his suspension bridge design as a "suspended" or "inverted" arch, since the road deck was hung from a catenary curve consisting of eyebars connected as trusses. When the War Department mandated the bridge's demolition in the 1920s, its unusual design was considered historic. Due to age and problems with anchorage slippage, the bridge was demolished before the adjacent Sixth and Ninth Street Bridges. (Carnegie Library of Pittsburgh.)

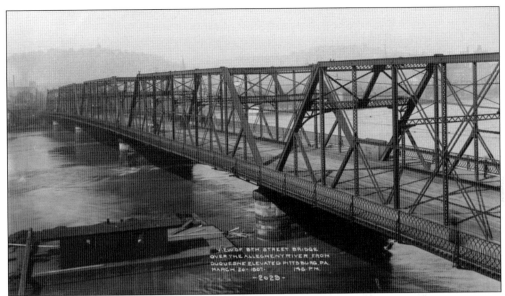

The first Hand (Ninth) Street Bridge, a covered wooden bridge, was constructed in 1839. Pleasant Valley Electric Street Railway Company purchased a controlling interest in the bridge company in 1889 to replace the bridge's wooden superstructure with stronger steel trusses to carry electric trolleys. Ferris, Kaufman & Company designed the Baltimore truss superstructure (pictured) in 1890. A year later, Ferris began designing the Ferris wheel, which debuted in 1893. (Carnegie Library of Pittsburgh.)

The 1890 Hand (Ninth) Street metal-truss bridge was constructed around the 1839 covered bridge to maintain traffic and toll revenue during construction. The new bridge was 12 inches higher—not enough to solve navigation issues. Demolition was not supposed to occur until after the new Seventh Street Bridge opened, but the original 1839 piers were rapidly deteriorating. Demolition began early in 1925, as shown here. (Carnegie Library of Pittsburgh.)

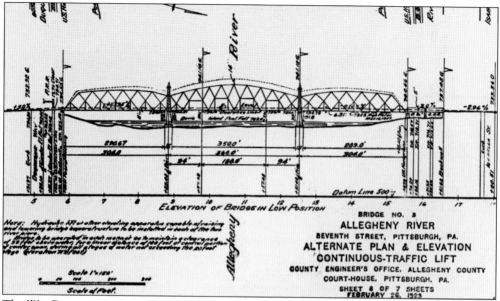

The War Department's mandated height clearances above high water created challenges for new bridges—they would need either steep grades or long approaches, impacting developed riverfronts. River levels fluctuated before dams were constructed in the 1930s, so novel continuous traffic-lift bridges were proposed. Spans could be lifted 14 feet when water levels were high while maintaining traffic across the raised bridge with sufficient clearance below. (Allegheny County Department of Public Works.)

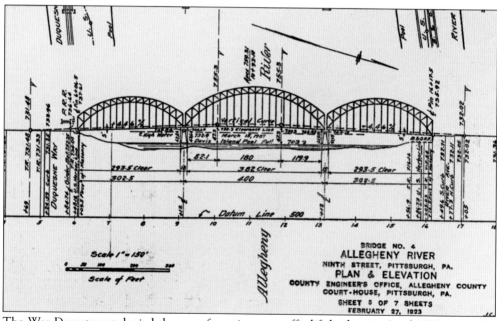

The War Department denied the use of continuous traffic-lift bridges in April 1923, since the concept was experimental. Other concepts were also presented, such as this three-span arch bridge for the crossing at Ninth Street. It was similar to the Sixteenth Street Bridge, which was under construction at the time. This concept showed undesirable roadway slopes of 4.46 percent. (Allegheny County Department of Public Works.)

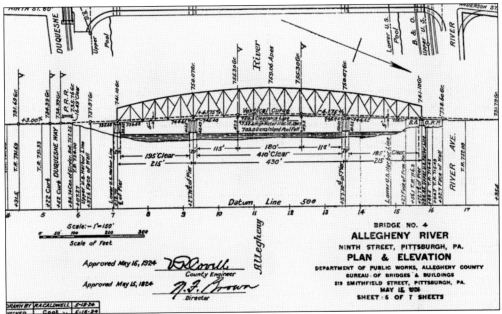

After the original concepts were rejected in 1923, new concepts were submitted in 1924. In one concept, to break the monotony of three identical parallel bridges, only the Sixth Street and Ninth Street bridges were proposed to have the same design—truss bridges with a top chord curving upward, as shown here. This design allowed flatter roadway slopes of 4.175 percent. (Allegheny County Department of Public Works.)

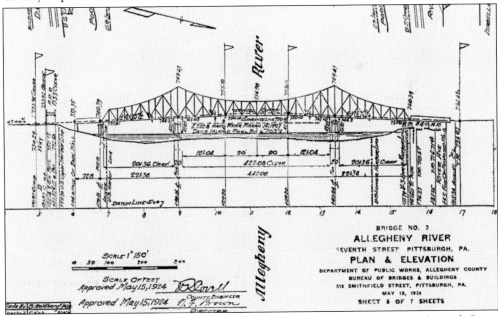

Contrasting with the proposed identical Sixth and Ninth Street bridges, the longer Seventh Street Bridge between them would be a cantilevered truss with the top chord curving downward, the inverse of the other bridges. The Municipal Art Commission rejected these designs, preferring three identical suspension bridges, since that bridge type has minimal structural members above deck, thereby preserving views of the city. (Allegheny County Department of Public Works.)

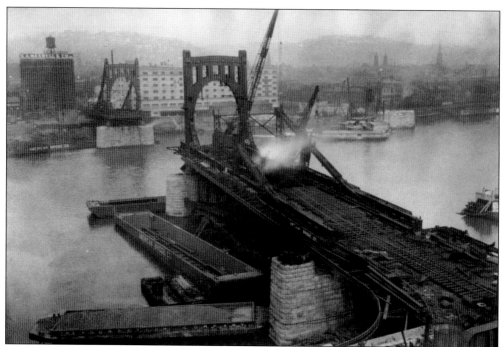

Previous Allegheny River suspension bridges had experienced problems with cable slippage at their anchorages. With buildings and an elevated railroad along the Allegheny River's downtown side, deep excavation for anchorages was impractical. County engineers chose a self-anchored suspension design, never before tried in America, but similar to the 1915 Cologne-Deutz Bridge in Germany. Construction of the Seventh Street Bridge began in 1925, as shown here. (Carnegie Library of Pittsburgh.)

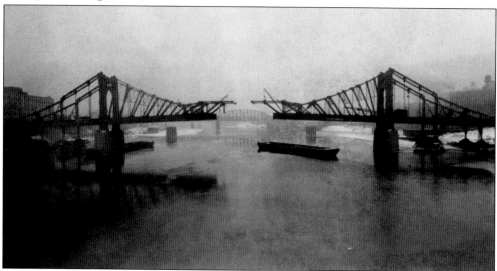

Self-anchored suspension bridges use stiffening members along the deck, tying the cable ends together to counter the cable's outward pull. The deck must be completed for the bridge to function. The American Bridge Company built the "Three Sisters" bridges (pictured) as cantilevered trusses, keeping the river channel clear. Eyebar chains were used, since wire rope could not resist the compressive forces introduced by the cantilevered construction. (Carnegie Library of Pittsburgh.)

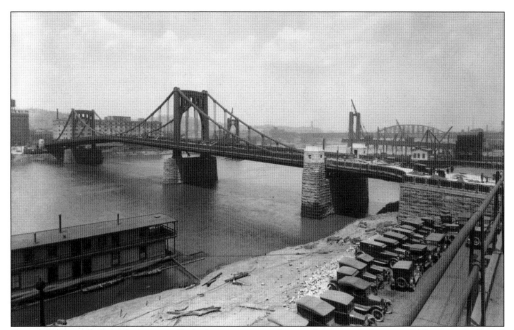

Once all structural steel was installed, the temporary diagonal truss members could be removed, and the bridge could function as a self-anchored suspension bridge. This June 1926 photograph shows the Seventh Street Bridge nearing completion, with the temporary truss members removed. The Ninth Street Bridge is visible under construction in the background. (Carnegie Library of Pittsburgh.)

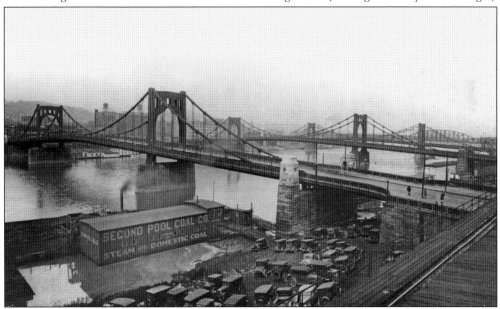

The Sixth Street Bridge (foreground) was completed in 1928, and the Seventh and Ninth Street Bridges were finished in 1926. They were designed as a trio for economy, using the same design, and for aesthetics, creating a scenic attraction along the downtown shoreline. They have received many awards and commendations and have been featured in movies. They are now named after baseball legend Roberto Clemente, artist Andy Warhol, and environmentalist Rachel Carson. (HDR Inc.)

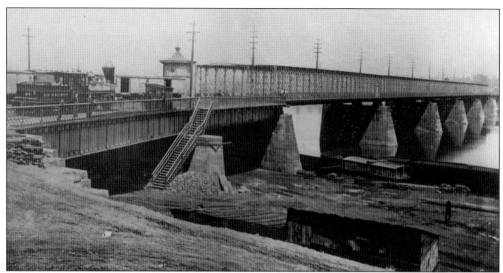

The Ohio & Pennsylvania Railroad, chartered in 1848, was connected to Pittsburgh in 1857 via a wooden bridge over the Allegheny River. The company became the Pittsburgh, Fort Wayne & Chicago Railway, which replaced the wooden bridge in 1864 with a wrought iron lattice-girder bridge, a design first used in America in 1859. The railroad was consolidated into the Pennsylvania Railroad as the Fort Wayne Division. (Carnegie Library of Pittsburgh.)

H.A. Gardner, chief engineer, and Felician Slataper, engineer-in-charge, designed the 1864 bridge. The 1,172-foot bridge had five riveted lattice spans, each 178 feet long. By 1900, the bridge had to be replaced because it could not carry the heavier locomotives. The superstructure was shifted to temporary piers built next to the bridge so rail traffic could continue while its replacement was constructed from 1901 to 1904. (Carnegie Library of Pittsburgh.)

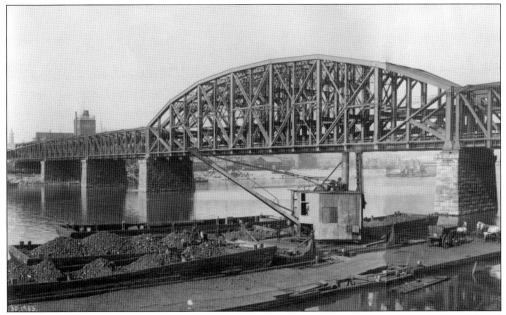

To accommodate railroad expansion and heavier locomotives, the Fort Wayne Division hired the American Bridge Company to construct a new bridge in 1901. To obtain a War Department permit, the railroad agreed to remove a pier to provide a 320-foot main-channel span, but it refused to pay to raise the bridge's clearance, since neighboring bridges were lower and had not yet been ordered to be raised. (Carnegie Library of Pittsburgh.)

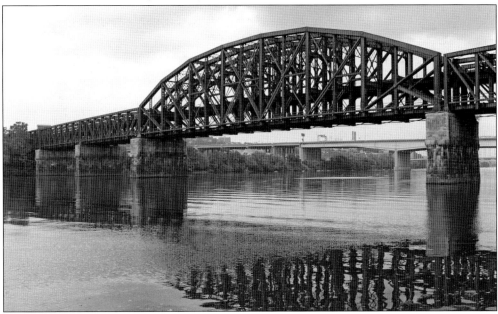

The Fort Wayne Railroad Bridge had two decks, separating local and through train traffic. Although the bridge was expandable to six tracks, only four tracks were built. In 1917, the War Department determined that the bridge had to be raised 13 feet. This occurred from October 1917 to March 1918, with all spans simultaneously raised 3 to 15 inches per day to maintain uninterrupted rail traffic. Concrete pier caps reveal elevation differences.

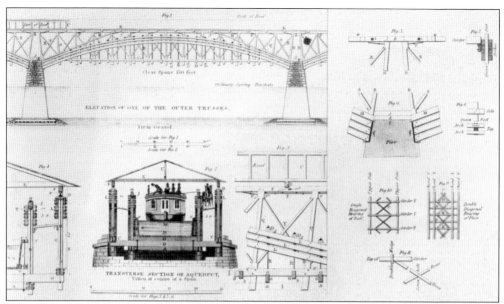

Early westward transportation routes bypassed Pittsburgh—the 1818 National Road was south, and the 1825 Erie Canal was north. Pittsburgh leaders campaigned in the state legislature to build a canal to Philadelphia. Routes along the Allegheny River were surveyed. The north bank was deemed more suitable, necessitating a wooden aqueduct across the Allegheny River to Pittsburgh at Eleventh Street, built in 1829. This illustration is from an 1842 issue of the *Journal of the Franklin Institute*.

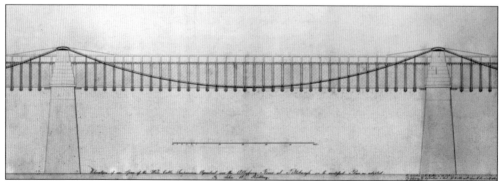

Canal engineer John Roebling pioneered the technique of twisting strands of wire into rope. He designed a low-cost replacement bridge for the maintenance-intensive Allegheny Aqueduct using wire rope, and successfully lobbied the canal company to build the bridge. He invented a mechanized process to band wire ropes together into cables to improve rigidity. Roebling's 1845 aqueduct was an immediate success, launching his renowned bridge-engineering career. (Rensselaer Polytechnic Institute Archives.)

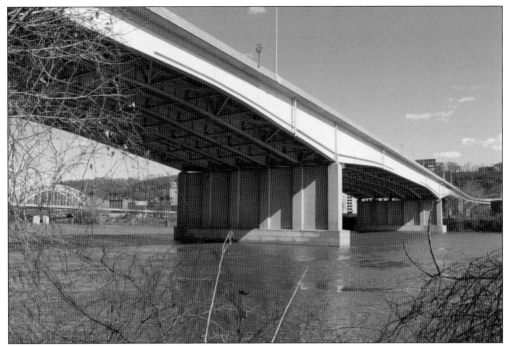

First envisioned in the 1930s, Crosstown Boulevard (I-579) was designed and constructed in the 1950s and 1960s to connect the Liberty Bridge to the planned East Street Valley Expressway via a proposed Allegheny River bridge. Work began in 1984, and the Veterans Memorial Bridge opened in 1989. The bridge is Pittsburgh's only major steel girder river crossing. It has a 410-foot main span.

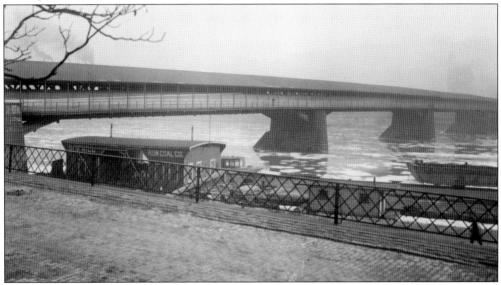

Pittsburgh's second vehicular bridge over the Allegheny River was the Mechanic (now Sixteenth) Street Bridge, constructed in 1837. It was a covered wooden bridge owned by Northern Liberties Bridge Company. It had to be rebuilt after an 1851 fire, and again following a flood in 1865. Such events were common problems for wooden bridges. Deemed an obstruction to navigation in 1917, the bridge was destroyed by fire in 1919. (Carnegie Library of Pittsburgh.)

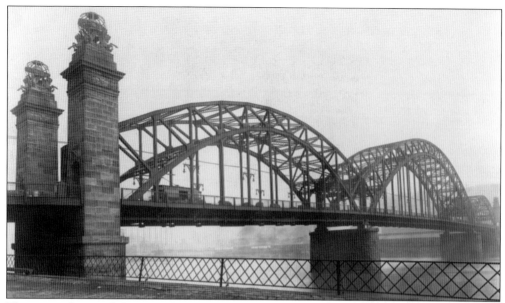

The present Sixteenth Street Bridge was completed in 1923. The longest of the bridge's three arches spans 420 feet. The bridge was Pittsburgh's first tied-arch bridge—the arches are tied together along the deck to counteract the horizontal thrust of the arches. Providing a higher clearance than its predecessor, the 1,996-foot bridge has long approaches over streets and railroad tracks at both ends. (Carnegie Library of Pittsburgh.)

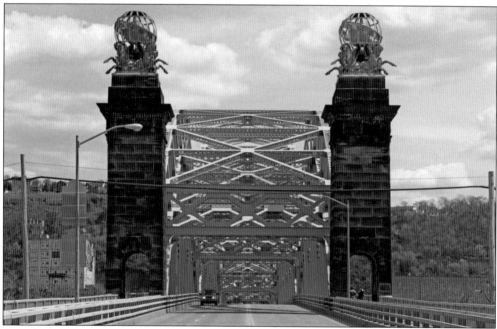

Civic bodies, such as Pittsburgh's art commission, requested that architects oversee the Sixteenth Street Bridge's design, rationalizing that civic bridges should be not just functional, but also beautiful. Warren & Wetmore of New York, with associate engineer H.G. Balcom, was commissioned to design the bridge. It features monumental pylons holding bronze armillary spheres by sculptor Leo Lentilli. The bridge was renamed for Pittsburgh-born historian David McCullough in 2012.

Stockyards were constructed on Herr's Island beginning in 1885. The West Penn Railroad extended a spur to the island in 1890. The Pennsylvania Railroad acquired the West Penn in 1903, consolidated its East Liberty stockyards on the island, and replaced the bridge with a Pratt truss. Abandoned in 1965, the bridge was rehabilitated and reopened for pedestrians in 1999. (Library of Congress, Prints & Photographs Division, HAER PA,2-PITBU,70—2.)

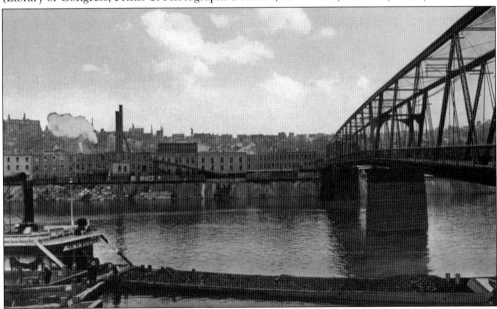

In 1887, a bridge designed by Gustav Lindenthal was constructed over the Allegheny River's main channel from Thirtieth Street in Lawrenceville to Herr's Island, where stockyards and slaughterhouses were being developed. The bridge was a wrought iron pin-connected continuous Warren through truss with a 305-foot main span and 228-foot side spans. The bridge's wooden deck caught fire in 1921, causing a spectacular collapse that destroyed the bridge and several coal barges underneath. (Pittsburgh History & Landmarks Foundation.)

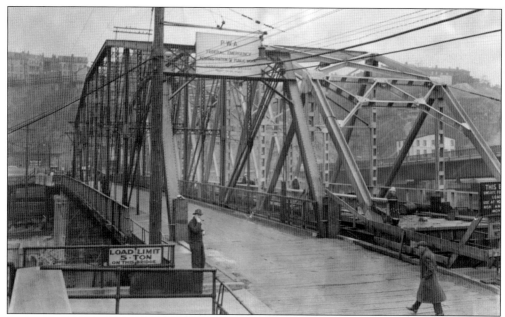

Spanning the Allegheny's back channel, Herr's Island Bridge was the first vehicular bridge to the island. It was destroyed by flood in 1882 and replaced the following year by a camelback Pennsylvania truss bridge (left) designed by the Pittsburgh Bridge Company. The bridge was raised in 1902 and repaired in 1924 after a truck crashed through the deck. The Federal Emergency Administration of Public Works funded construction of a new structure (right) in 1938–1939. (Carnegie Library of Pittsburgh.)

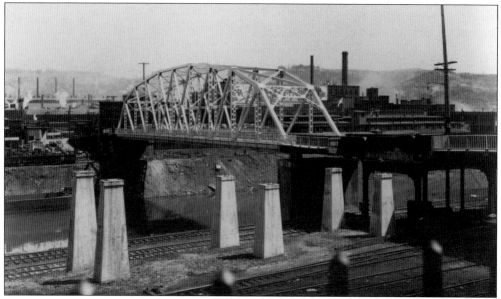

Built with Federal Emergency Administration of Public Works funding and designed by the Pittsburgh Department of Public Works, the new Herr's Island (Thirtieth Street) Bridge opened in 1939. The Eichleay Engineering Corp. built it beside the previous bridge and slid it into place. The main span was a Parker truss. It was replaced by a steel girder bridge in 1986 when the island was redeveloped. (Pittsburgh Department of Public Works.)

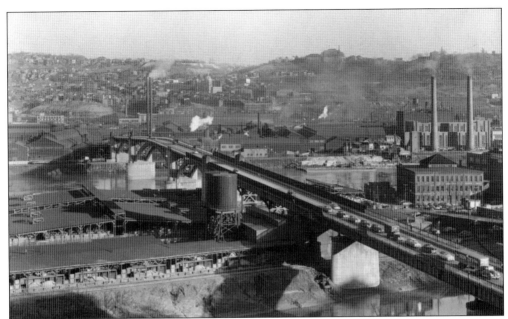

The 1887 Thirtieth Street Bridge's replacement was built at Thirty-first Street in 1927–1928. As shown here, the Thirty-first Street Bridge crossed both Allegheny River channels and Herr's Island. It was designed by Allegheny County DPW engineers Vernon Covell and Norman Brown. The bridge was similar to the nearby Washington Crossing (Fortieth Street) Bridge, built four years prior, but it was simpler in design. (Carnegie Library of Pittsburgh.)

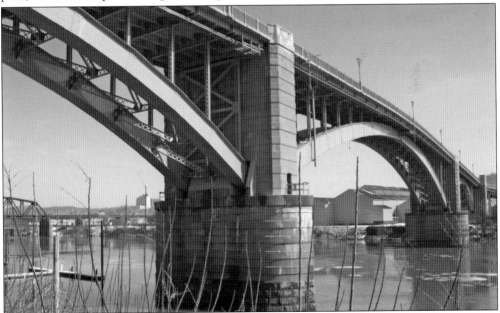

Pittsburgh's art commission rejected the Thirty-first Street Bridge's proposed through truss design in 1923, preferring arches beneath the road and unobstructed views from the deck. This required a longer, costlier bridge that could not directly connect to Herr's Island. Opened in 1928, the bridge has a 360-foot main span and a total length of 2,601 feet. Its Herr's Island back-channel spans were replaced in 2010–2013 for Route 28 interchange construction.

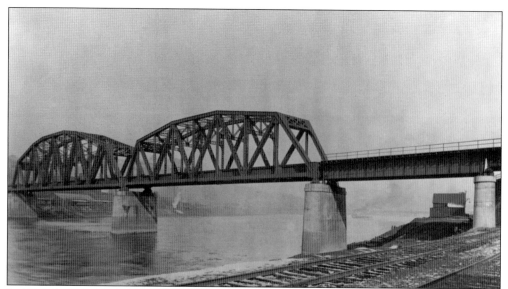

In 1884, the Pittsburgh Junction Railroad constructed its line across the Allegheny River through Herr's Island, with separate bridges over main and back channels. The main-channel bridge was declared an obstruction to navigation in 1917. The American Bridge Company replaced it with this Warren truss bridge in 1921–1923. To provide nearly level grades for locomotives, the higher bridge stretched nearly 4,300 feet and crossed above Herr's Island. (American Bridge Company.)

When the Pittsburgh Junction Railroad replaced its Allegheny River main-channel span in 1921–1923, the new, higher bridge did not connect to Herr's Island. The railroad retained its previous back-channel bridge to keep its connection to the island. The skewed pin-connected Pratt through truss was likely constructed by the Iron City Bridge Works in 1884. The bridge was used until the railroad spur was abandoned around 1965.

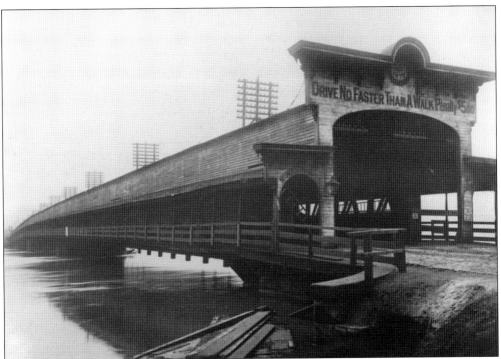

In 1870, a covered wooden toll bridge was constructed across the Allegheny River connecting Forty-third (Ewalt) Street in Lawrenceville with Millvale Borough. It was declared an obstruction to navigation in 1917 because of its short spans (244 feet) and low vertical clearance (27.7 feet). In 1922, severe winds pushed it out of plumb. The roof was removed, and the bridge was anchored with steel bracing until its replacement opened in 1924. (Carnegie Library of Pittsburgh.)

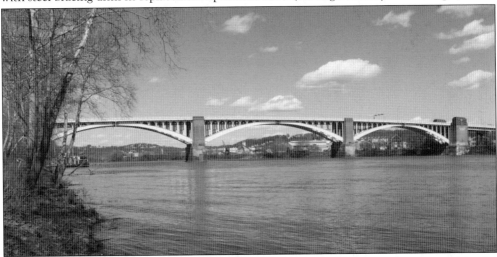

The Washington Crossing Bridge opened in 1924, one hundred seventy-one years to the day George Washington crossed the Allegheny River nearby. Architect Benno Janssen and engineer Charles Davis designed the bridge. It was built three blocks downstream from the previous bridge at higher ground, permitting the deck arch design favored by the art commission and eliminating at-grade railroad crossings. Embellishments included obelisks, escutcheons concealing hinges, and railings with the seals of America's 13 original colonies and Allegheny County.

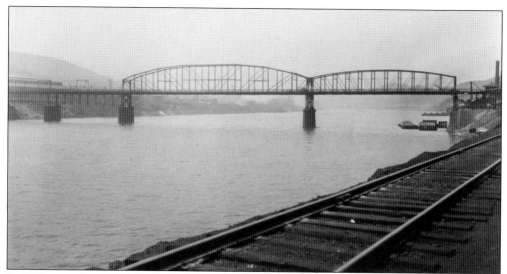

In 1856, a wooden covered bridge was constructed over the Allegheny River connecting Sharpsburg with Collins Township, now part of Pittsburgh. Low in height and often blocked by busy railroad traffic, the bridge was replaced by a higher one in 1899–1900. The steel truss bridge (pictured) had a 366-foot Pennsylvania truss main span, a 226-foot Parker truss side span, and deck truss and girder approach spans. (Carnegie Library of Pittsburgh.)

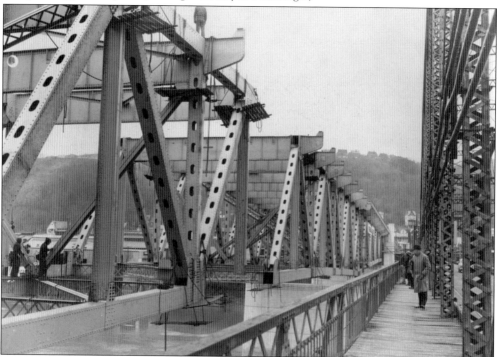

Unable to handle increasing traffic, the Sharpsburg Bridge was replaced beginning in 1960. This March 1961 photograph shows superstructure erection of the new Sixty-second Street Bridge. The new truss bridge was constructed by the American Bridge Company. The photograph, taken from the old bridge, shows how far bridge-building technology had progressed in the 60 years that separated the two bridges. (Carnegie Library of Pittsburgh.)

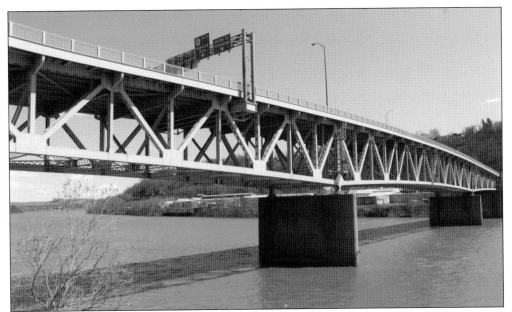

The Sixty-second Street Bridge was completed in July 1962. It is a cantilevered Warren deck truss with a 400-foot main span and a total length of 2,016 feet. The bridge was built as part of a larger project to upgrade Route 8 and Route 28, bypassing the boroughs of Etna and Sharpsburg. The bridge was named after Robert D. Fleming, a politician from Sharpsburg who served for over 30 years.

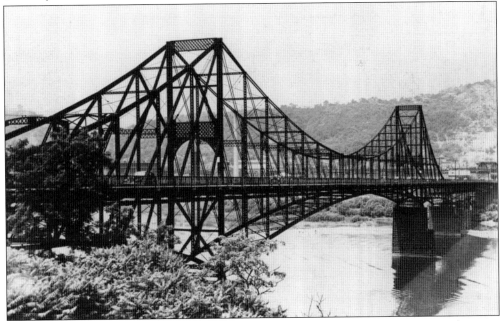

The first Highland Park Bridge, designed by Herman Laub, was constructed in 1902 between Pittsburgh and Sharpsburg. The bridge was 1,850 feet long, crossing over Sixmile Island in the Allegheny River. The main-channel span (left) was a cantilever through truss, and the back-channel span (far right) was a simple through truss. The bridge was replaced in 1939. (Allegheny County Department of Public Works.)

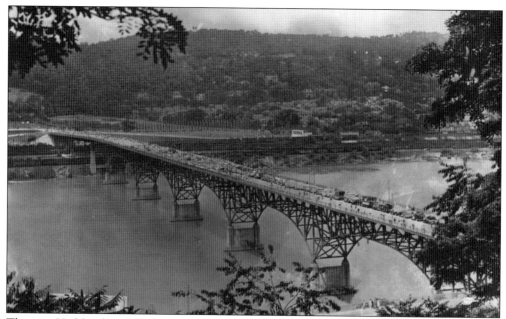

The new Highland Park Bridge opened in June 1939. It was designed by the Allegheny County Department of Works and funded through the Federal Emergency Administration of Public Works. The deck cantilever truss consists of five river spans, each 278 feet long. Since it was built near a lock, it was not required to have a 400-foot main span like other Allegheny River bridges built in Pittsburgh after 1917. (Allegheny County Department of Public Works.)

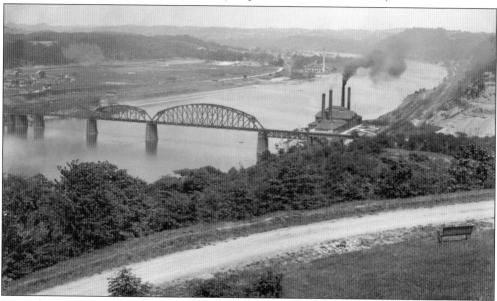

Pennsylvania Railroad's Brilliant Cutoff was constructed from 1903 to 1904. The rail line had several bridges, including this Parker through truss over the Allegheny River, seen from Highland Park. The cutoff was constructed to connect the Pennsylvania Railroad's mainline in Homewood with the line along the Allegheny River, bypassing downtown Pittsburgh. The railroad eventually abandoned the Brilliant Cutoff, which was purchased by the Allegheny Valley Railroad in 1995. (Library of Congress.)

Three

MONONGAHELA RIVER BRIDGES

Almost from the time that Europeans first ventured into Western Pennsylvania in the 1700s, the Monongahela River has been a working river. Settlements and industries formed early along its 127-mile length, because it offered a relatively easy way northwestward from Maryland and Virginia. The National Road, completed in 1818, was initially built from the Potomac River at Cumberland, Maryland, to the Ohio River at Wheeling, Virginia (now West Virginia). The road passed through Brownsville, Pennsylvania, about 40 miles south (upstream) of Pittsburgh. From Brownsville, travelers could use the Monongahela River to reach Pittsburgh and the Ohio River.

The Monongahela Navigation Company was incorporated in 1817 to improve navigation along the river by constructing locks and dams that permitted slack-water navigation from Brownsville to Pittsburgh by 1844. Uninterrupted steamboat traffic was crucial for transporting coal to Pittsburgh's growing industries. The company pressed for river bridges to be built with longer spans and higher vertical clearances, to allow unobstructed navigation.

The Monongahela River's importance as a conduit was further enhanced when Pennsylvania, in an effort to compete with the Erie Canal, completed its Main Line of Public Works (Pennsylvania Canal) from Pittsburgh to Philadelphia in 1834. The canal was extended through downtown Pittsburgh to the Monongahela River, enabling the river to connect both canal and National Road traffic with the Ohio River.

As Pittsburgh's population and industries grew in the 19th century, more bridges were needed to connect the city with the developing communities across the river. The constraints that the river interests imposed on bridges allowed the Monongahela River to develop into an industrial river, unlike the Allegheny, which was obstructed by low bridges through the 1920s. These constraints led to a variety of unprecedented engineering solutions, as the engineers had to design higher bridges with longer spans, some exceeding 500 feet.

This chapter describes the Monongahela River bridges that helped Pittsburgh develop into the industrial powerhouse of the nation.

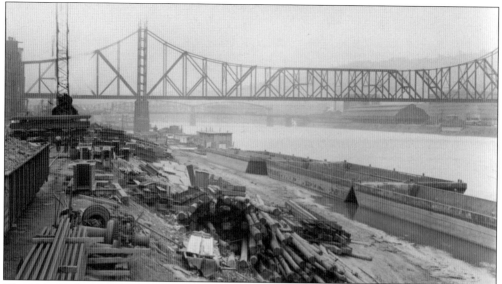

The 1904 Wabash Bridge was an early long-span cantilever bridge, constructed for George J. Gould's Wabash Pittsburgh Terminal Railway, which entered the Pennsylvania Railroad–dominated Pittsburgh market too late to be successful and went bankrupt in 1908. Rail traffic continued on the bridge until 1946, when a massive fire destroyed its rail facilities in Pittsburgh. The bridge was demolished in 1948. Its piers and adjoining tunnel through Mount Washington remain. (Pittsburgh Department of Public Works.)

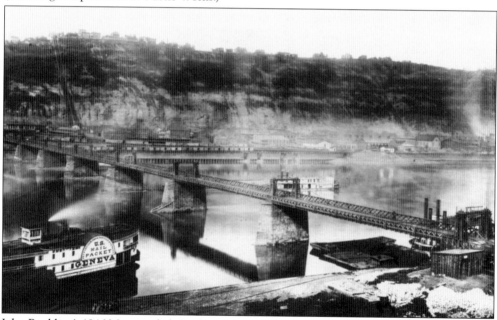

John Roebling's 1846 Monongahela Bridge at Smithfield Street was built on the piers of Pittsburgh's first river bridge, an 1818 Lewis Wernwag–designed covered bridge. It connected Pittsburgh to Sycamore Street, which climbed Mount Washington. Roebling's Pennsylvania Canal Allegheny Aqueduct was under construction when Pittsburgh's 1845 Great Fire burned the wooden Monongahela Bridge. Submitting the lowest reconstruction bid, Roebling fitted his suspension design atop the surviving piers. (Carnegie Library of Pittsburgh.)

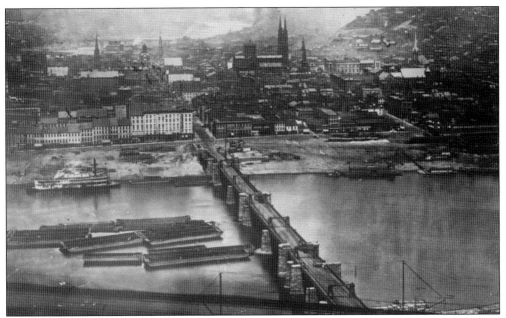

The Monongahela Bridge Company authorized construction of a new suspension bridge with longer spans in 1880 to replace Roebling's 1846 bridge. The severe winter of 1880–1881 halted pier construction. The company was reorganized, and the new management hired Gustav Lindenthal to design a truss bridge using the unfinished piers. The piers were extended above the old bridge, which remained open while the new bridge was built overhead. (Carnegie Library of Pittsburgh.)

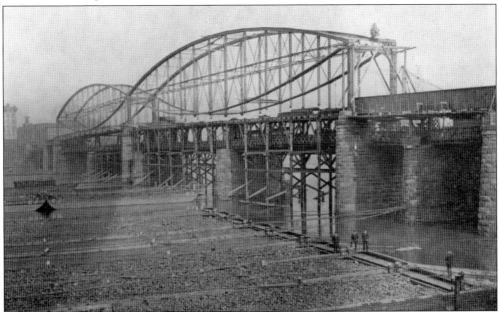

The new Smithfield Street Bridge is shown under construction around 1882. The work is taking place above the 1846 suspension bridge. The lenticular truss design was chosen because the bridge company hoped to expand the bridge to carry rail traffic. The suspension design had been neither rigid nor expandable. Lenticular trusses used less material than other trusses and were thought to have a pleasing appearance appropriate for an urban setting. (Carnegie Library of Pittsburgh.)

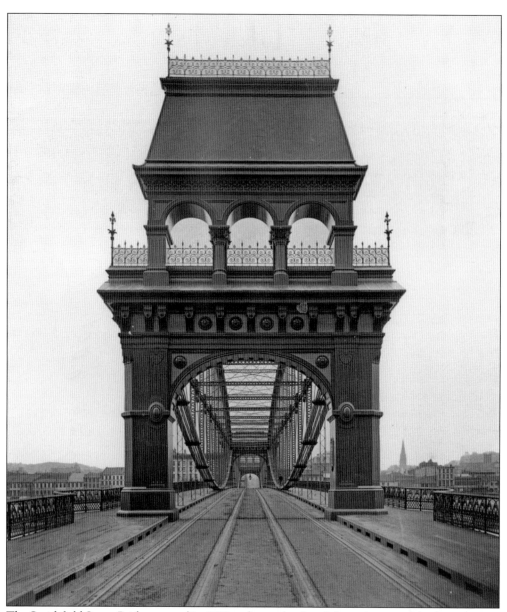

The Smithfield Street Bridge opened in 1883 and was a landmark from the start. It had ornate cast-iron portals painted the color of stone, with blue lenticular trusses and brown flooring. The bridge initially had two lanes. It was designed for expansion, so the trusses were not placed symmetrically over the piers. The trusses were on the downstream side, allowing the bridge to be widened on its upstream side. Engineer Gustav Lindenthal became known for designing unconventional bridges that bucked trends with aesthetically pleasing structural forms influenced by his appreciation of art. Most early 1880s bridges were made from wrought iron, but Lindenthal specified that the highest quality open-hearth steel be used. The wrought iron ordered for the original 1880 design was used for the bridge's flooring and approach girders. The bridge is the longest-spanning lenticular truss in the United States and is a National Historic Landmark. Lindenthal went on to design other noted bridges, including New York's Hell Gate and Queensboro Bridges. In 1902, he became New York's commissioner of bridges.

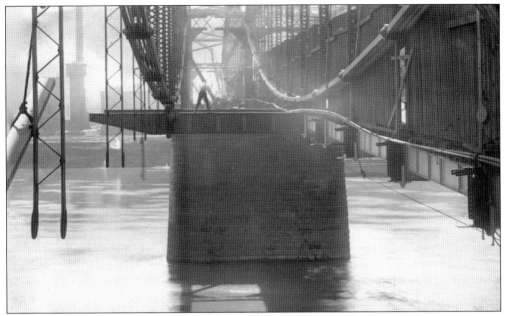

The Smithfield Street Bridge's original design included provisions for widening its upstream side for a railroad. Widening occurred in 1889, but the addition was built for streetcars. In 1904, a tunnel opened through Mount Washington at the end of the bridge, increasing streetcar traffic. The bridge was widened again in 1911 (pictured), allowing streetcars to run in both directions on the bridge's upstream side. (Pittsburgh Department of Public Works.)

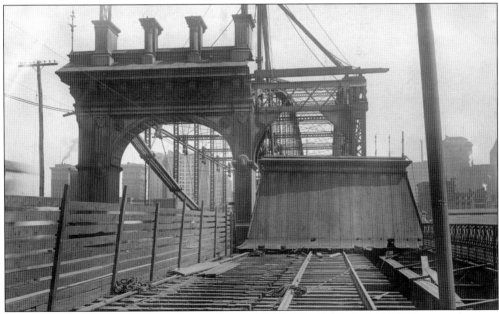

When the Smithfield Street Bridge was widened for the second time in 1911, questions arose as to what to do with the bridge's original cast iron portals. Since they were deteriorated and out of style, they were removed. Here, the portal's south canopy has been removed and placed on the deck in July 1911. The rest of the portal was subsequently removed. (Pittsburgh Department of Public Works.)

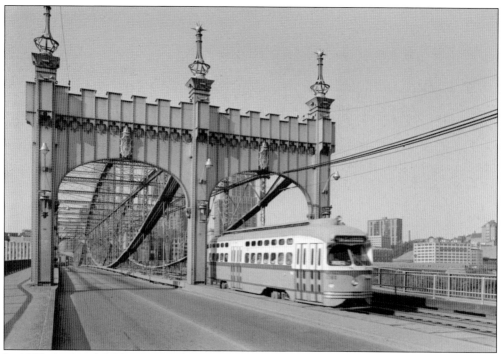

In 1895, the Smithfield Street Bridge was purchased by the city, which removed the tolls. The city's architect, Stanley Roush, designed new steel portals, which were installed in 1915. The portals had fortress-like entryways featuring the city's coat of arms rising from the backs of the miners and manufacturers immortalized in sculpture. (Library of Congress, Prints & Photographs Division, HAER PA,2-PITBU,58—16.)

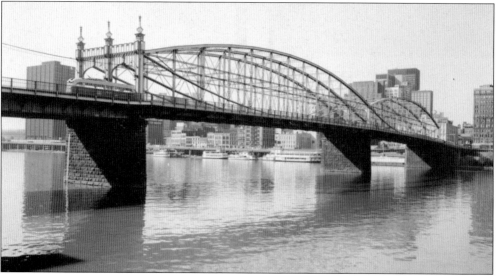

The Smithfield Street Bridge was altered and modernized several times. The original iron roadway was replaced with lightweight aluminum in 1934, a bridge-building experiment. A replacement aluminum bridge deck was installed in 1967. Streetcar traffic was discontinued on the bridge in 1985. In 1994–1995, the bridge was rehabilitated, and the former streetcar side was converted to vehicular use. (Library of Congress, Prints & Photographs Division, HAER PA,2-PITBU,58—11.)

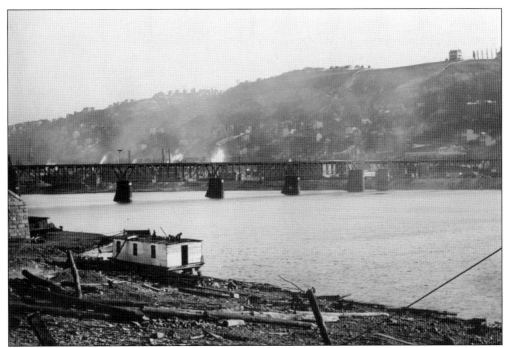

Construction began on the Pittsburgh & Steubenville Railroad Monongahela River Bridge in 1856 and was completed in 1863. The bridge's main span, built by Pittsburgh's Keystone Bridge Company, consisted of a cast iron and wrought iron Whipple through truss with tubular members. The approach spans were covered wooden deck trusses. Around 1874, the approaches were replaced with Whipple deck trusses, seen here in 1887. (Carnegie Library of Pittsburgh.)

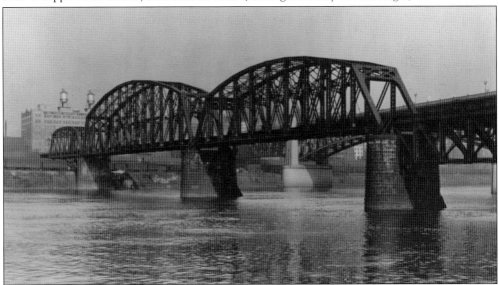

The Pittsburgh & Steubenville Railroad eventually became Pennsylvania Railroad's Panhandle Division, named for its route through West Virginia's Panhandle. In 1903, the previous bridge was replaced with the current pin-connected Pennsylvania truss, built by the American Bridge Company. It was raised in 1912–1914 for a grade-separation project. The bridge was modified around 1920 when the northernmost truss (far left) was replaced. (American Bridge Company.)

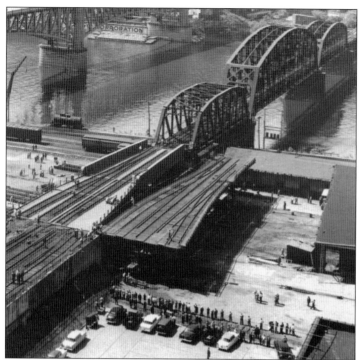

In 1955, construction of the Penn-Lincoln Parkway along the Monongahela River required modifications to the Panhandle Bridge. To keep rail traffic operational, a new approach was constructed next to the previous approach. With only a short interruption in rail traffic, the Eichleay Engineering Corporation slid the new approach in place (pictured). The bridge was modified again in 1985, when it was converted for light-rail use. (Eichleay Corporation Archives.)

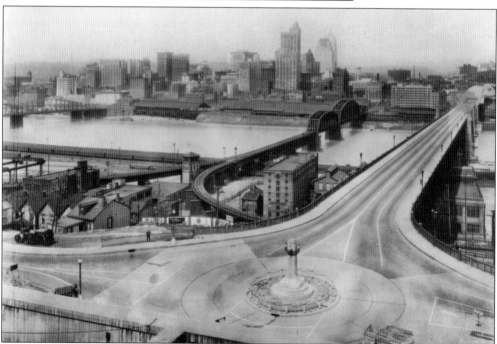

The largest and most expensive bridge constructed over Pittsburgh's rivers at the time was the 1928 Liberty Bridge, shown here in 1933. The bridge has two 420-foot cantilevered main spans. It was once adorned with concrete pylons that extended above the deck, decorative shell-motif forged steel railings and lampposts, and a monument at a traffic circle between the bridge and Liberty Tunnels. (Pittsburgh Department of Public Works.)

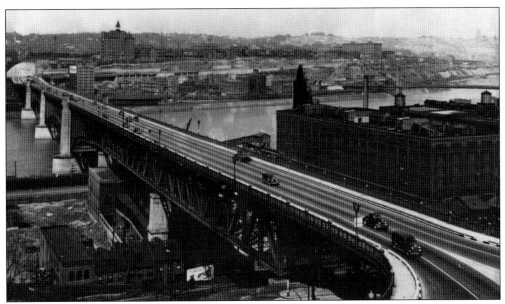

The Liberty Bridge and Liberty Tunnels were instrumental in the development of the South Hills. Before their construction, Mount Washington was penetrated only by the trolley tunnel, or traversed by inclines or steep roads. The Allegheny County DPW designed the bridge and tunnel to connect West Liberty Avenue through Mount Washington to downtown Pittsburgh and the Boulevard of the Allies. (Allegheny County Department of Public Works.)

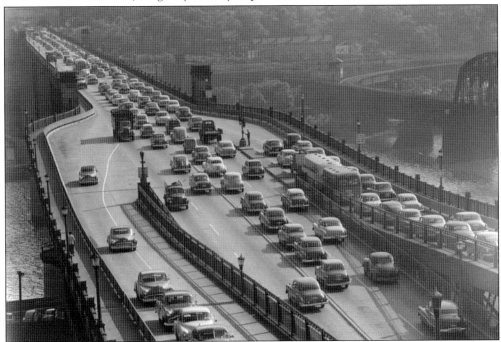

The Liberty Bridge became a traffic bottleneck. The traffic circle was reduced in size and then removed. A reversible lane plan was instituted, allowing three inbound lanes in the morning and three outbound lanes in the evening, as shown here. Reversible tunnel lanes were implemented for a time. The bridge was rehabilitated and widened in 1983. (Carnegie Library of Pittsburgh.)

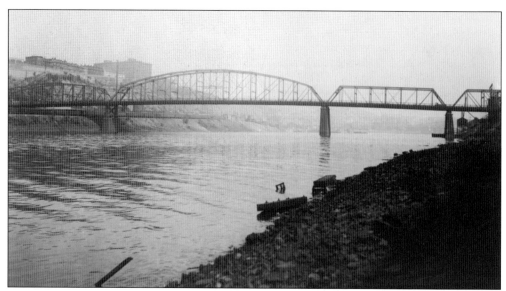

An 1861 covered bridge at present-day Tenth Street was Pittsburgh's second Monongahela River crossing. It was replaced by a steel truss bridge in 1904. The bridge, seen here in 1930, had a Pennsylvania truss main span flanked by a Parker truss to the north and Pratt trusses to the south. The bridge was designed by the Pittsburgh Department of Public Works and constructed by the American Bridge Company. (Carnegie Library of Pittsburgh.)

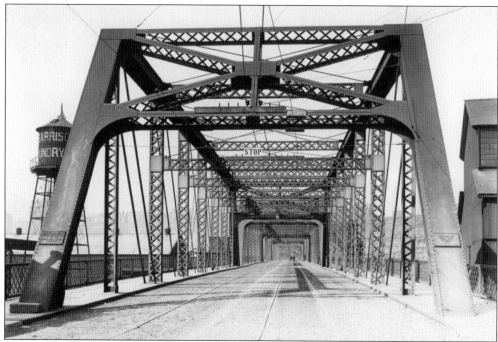

This 1913 portal view of the 1904 Tenth Street Bridge looks north toward present-day Duquesne University perched atop Boyd's Hill. The Armstrong Tunnel was constructed through the hill in 1927. The Fort Pitt Incline connected the previous covered bridge to Magee Street by Duquesne University. The incline closed around the time the 1904 bridge was constructed. (Pittsburgh Department of Public Works.)

The Allegheny County DPW anticipated increased traffic along Tenth Street due to the 1927 opening of the Armstrong Tunnel and the 1935 opening of lower Mount Washington (McArdle) Roadway. The county decided to replace the Monongahela bridge between the tunnel and roadway. The 1904 bridge was demolished in 1931, and a new suspension bridge was completed in 1933. It is seen here just before opening. (Carnegie Library of Pittsburgh.)

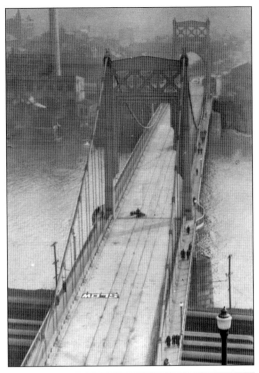

The 1933 Tenth Street Bridge was the first cable suspension bridge built in Pittsburgh since the city's Roebling-designed bridges of the mid-1800s. The city's art commission advocated the suspension design. The bridge, designed by George Richardson, has a main span of 725 feet, the longest over the Monongahela River. In 2007, the bridge was renamed the Philip Murray Bridge, for the United Steelworkers Union's first president. (HDR Inc.)

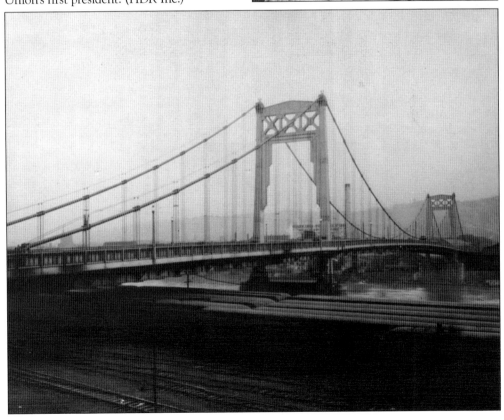

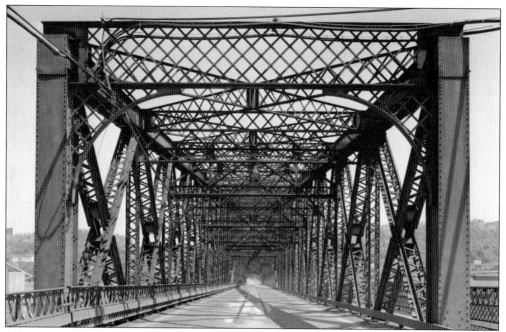

After Birmingham (South Side) was annexed by Pittsburgh in 1868, residents were frustrated that all Monongahela River bridges into the city had tolls. After years of agitation, the Brady Street Bridge was built as Pittsburgh's first free river bridge and the second to be owned by the city. It was constructed in 1895–1896 by the Schultz Bridge & Iron Company. (Library of Congress, Prints & Photographs Division, HAER PA,2-PITBU,31—16.)

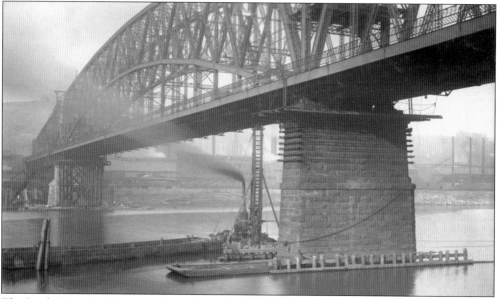

The Brady Street Bridge experienced problems with piers cracking soon after it opened. By 1909, the northern river pier, visible here in the background, had settled 16 inches. The John Eichleay Jr. Company was hired to raise the bridge onto falsework so the Dravo Contracting Company could replace the piers. This 1910 photograph shows falsework surrounding the northern pier and pile driving for falsework around the southern pier. (Pittsburgh Department of Public Works.)

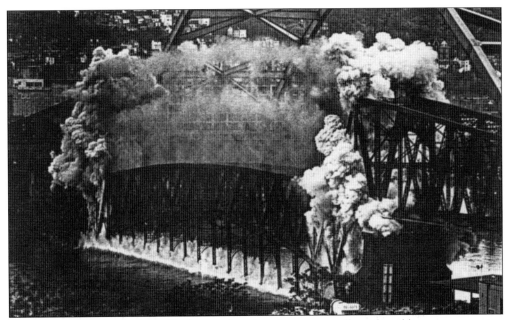

By the 1960s, the Brady Street Bridge was deteriorating structurally and unable to meet growing traffic demands. Its replacement, the Birmingham Bridge, opened in 1976. Brady Street Bridge demolition did not go smoothly. While undergoing prep work, the bridge shifted, trapping an ironworker, who lost his leg. Engineers feared the unstable structure would collapse into the Birmingham Bridge. On Memorial Day 1978, the main span was blasted into the river.

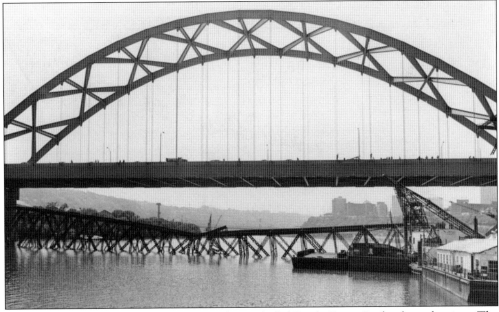

It took six days for contractors to remove the imploded Brady Street Bridge from the river. The 607-foot tied arch Birmingham Bridge behind it was completed in 1976, years after its piers were constructed in 1969. Planned to be part of a highway from the South Side through Oakland to the Allegheny River valley, the bridge has stubs for ramps that were never built. (Carnegie Library of Pittsburgh.)

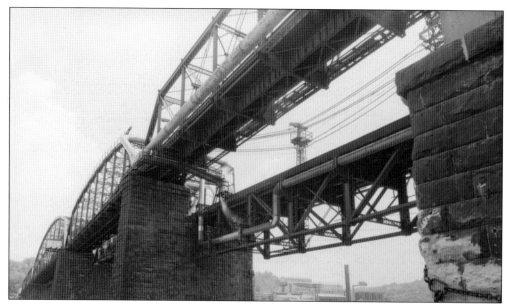

Iron was smelted at Eliza Furnaces, cast into pig, ferried across the Monongahela River, and reheated for production at Jones and Laughlin's American Iron Works. The process was streamlined when a hot-metal bridge was constructed in 1887 to carry molten iron directly across the river. The bridge's superstructure was replaced in 1901 and was widened with an upstream bridge in 1904. (Library of Congress, Prints & Photographs Division, HAER PA,2-PITBU,65C—6.)

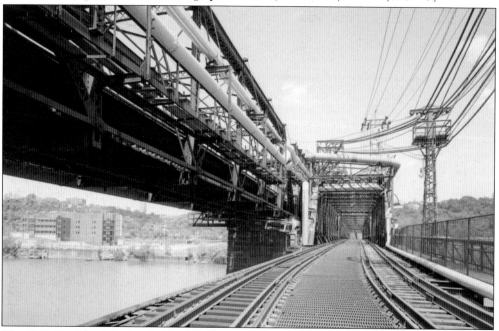

The 1901 Hot Metal Bridge (left) originally had a fireproof brick deck, replaced by steel plate in 1960 to lighten the bridge for heavier railcars. It was converted to pedestrian and bicycle use in 2007. The 1904 Monongahela Connecting Railroad Bridge (right) carried intra-mill shipments and exports until it was closed in 1993 and converted to vehicular use in 2000. (Library of Congress, Prints & Photographs Division, HAER PA,2-PITBU,65C--8.)

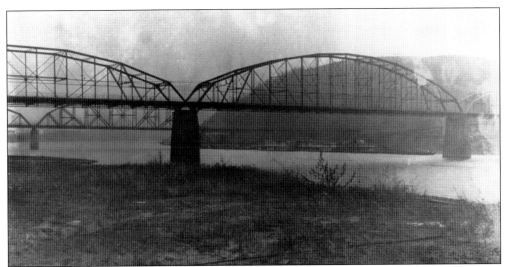

The Glenwood Bridge Company was chartered to construct a bridge across the Monongahela River between Glenwood and Hays. Completed in 1895, the bridge carried streetcars of the Second Avenue Traction Company (later Pittsburgh Railways Company). The bridge was built by the Penn Bridge Company of Beaver Falls. The main Pennsylvania truss span was 517 feet long, one of the longest simple spans built anywhere at the time. (Allegheny County Department of Public Works.)

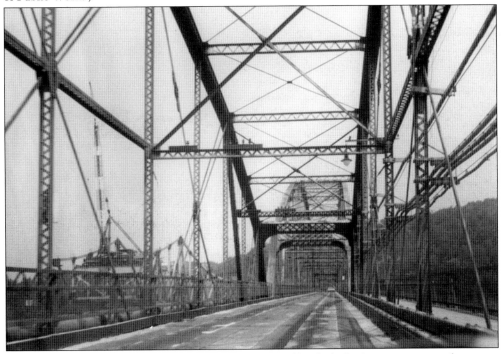

The Glenwood Bridge carried trolleys until 1964. Frustrated by the lack of progress on its replacement, vandals damaged the wooden bridge deck in 1964, and protesting residents blocked the bridge for three days. The bridge was repaired and reopened until its replacement opened in 1968. This 1967 photograph shows the new Glenwood Bridge under construction next to the 1894 span. (Dr. Steven Fenves collection.)

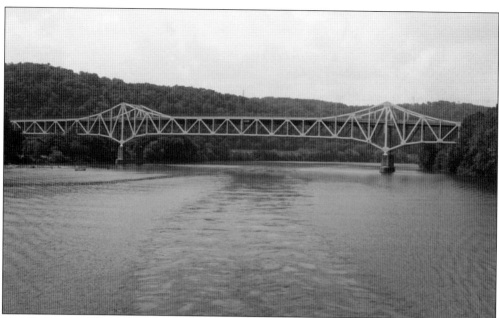

The Glenwood Bridge, designed by Richardson, Gordon & Associates, opened on December 20, 1968. It was planned for a highway that was never built. Its continuous truss requires greatest structural depth over piers to resist bending. To minimize depth, trusses extend above as well as below the road at the piers. Truss members are formed of welded steel-box sections, the first such use in the region. This method reduced weight by 16 percent.

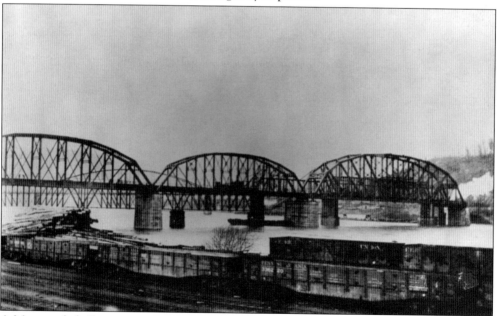

A Monongahela River crossing was constructed for the Wheeling Branch of the Baltimore & Ohio Railroad between Hays and Glenwood in 1884 to connect its main line in Washington, Pennsylvania, with its Glenwood Yard and its line along the river. Here, the original Whipple truss is being replaced by the current Pennsylvania truss bridge in 1915. The American Bridge Company constructed the new crossing. (American Bridge Company.)

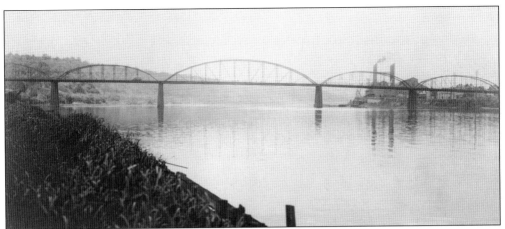

The Homestead & Highland Bridge was known as Brown's Bridge because it was built by a group of investors led by steamboat company owner Capt. Samuel S. Brown. Carrying the Schenley Park, Highland & Homestead trolley line, the five-span Parker through truss bridge opened around 1897, connecting the bustling steel town of Homestead with Pittsburgh's East End. The 1,300-foot bridge carried trolleys, pedestrians, carriages, and, later, automobiles.

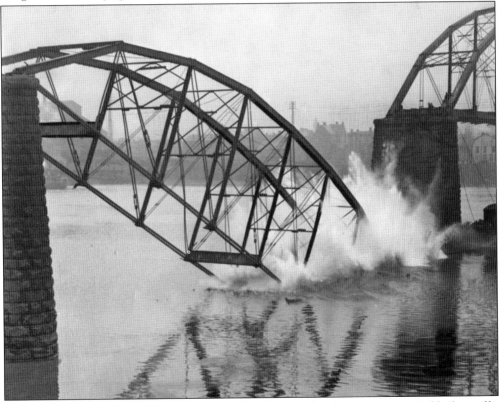

By the 1920s, Brown's Bridge was a bottleneck. The nine-foot lanes were unsuitable for traffic serving the Homestead Steel Works. Approximately 180 trains per day blocked rail crossings in Homestead for an average of two hours per day. After the 1937 Pittsburgh-Homestead High Level Bridge opened downstream, Brown's Bridge was dropped into the river, span by span, as shown in this February 1938 photograph. (Carnegie Library of Pittsburgh.)

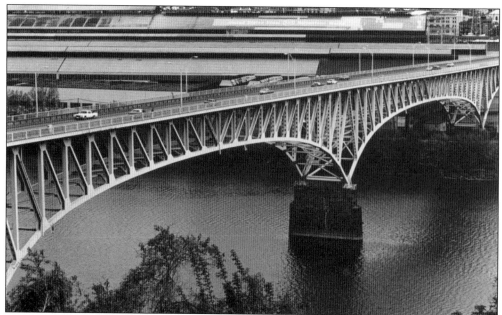

The 1937 Pittsburgh-Homestead High Level Bridge crossed the Monongahela River, lower Homestead, and the railroads. In 1941, buildings in lower Homestead were demolished, and the steel mills were expanded up to the bridge, as shown here. The mills were removed in the 1990s and replaced with the Waterfront mixed-use complex. In 2002, the bridge was renamed the Homestead Grays Bridge, after Homestead's famous Negro League baseball team. (Dr. Steven Fenves collection.)

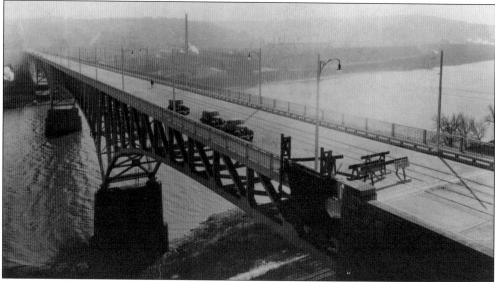

The Homestead Grays Bridge was the first to use the Wichert self-adjusting truss, a hinged diamond assembly invented in 1930 by Pittsburgh engineer E.M. Wichert. With diamond-shaped openings over piers, Wichert trusses allowed otherwise continuous spans to flex independently, rendering them statically determinate for engineering calculations. The bridge was designed by the Allegheny County Department of Works, funded by the Works Progress Administration, and built by American Bridge. It is shown just before its 1937 opening. (American Bridge Company.)

Four

Ohio River Bridges

The Monongahela and Allegheny Rivers converge at Pittsburgh to form one of America's largest rivers—the Ohio. Its name, given by the Seneca, means "the good river." Stretching 981 miles from Pittsburgh to join the Mississippi River at Cairo, Illinois, the good river became one of the greatest navigation and trade routes into America's interior. The Ohio River was a primary route west for settlers in search of land and opportunity, giving Pittsburgh, the city at its origin, the title "Gateway to the West."

Bridges were constructed across the Ohio River much later than across the Monongahela or Allegheny Rivers. Pittsburgh's first river bridges were built in 1818 over the Monongahela River and in 1819 over the Allegheny River. In Pittsburgh, the first railroad crossing over the Ohio River was not constructed until 1890, and the first vehicular crossing not until 1931, 113 years after Pittsburgh's first river bridge was built.

Pittsburgh grew and developed outward from the Point, so roads were constructed along rivers and valleys primarily for travel to and from downtown. These roads did not require bridges over the Ohio River. It was not until downtown Pittsburgh became congested with roads and railways that the city needed western bypasses across the river.

In the 1800s, it was prohibitively expensive to span the Ohio River because almost all bridges were privately financed. The river's width and strong current made it the most difficult and costly of Pittsburgh's three rivers to span. Meanwhile, it was Pittsburgh's main conduit for shipping products to the west. River interests fought to keep the Ohio River free from potentially obstructive crossings. This became more and more important as locks and dams were constructed along the river from 1885 to 1929. Bridges were permitted to be constructed across the Ohio River only if they could be erected without impeding river traffic. Given the river's strategic importance, the US War Department imposed span length requirements for Ohio River bridges.

All of these challenges meant that, when bridges were finally built over the Ohio River, they were innovative, record-breaking structures. This chapter tells the story of Pittsburgh's impressive Ohio River bridges.

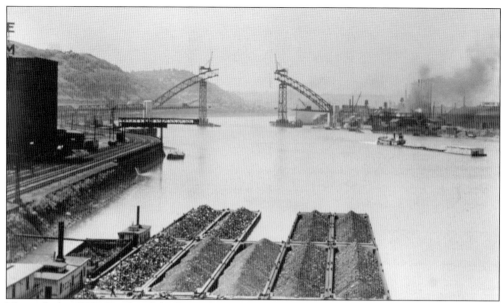

Through the 1920s, Pittsburgh had no vehicular bridges over the Ohio River. In 1912, businessman Henry Tranter began campaigning for a bridge connecting Pittsburgh's North Side with Saw Mill Run valley and the West End. After years of advocacy, Allegheny County's 1928 bond issue included funding for Saw Mill Run Boulevard and Tranter's West End Bridge, shown under construction in 1931. (Library of Congress, Prints & Photographs Division, HAER PA,2-PITBU.V,3—35.)

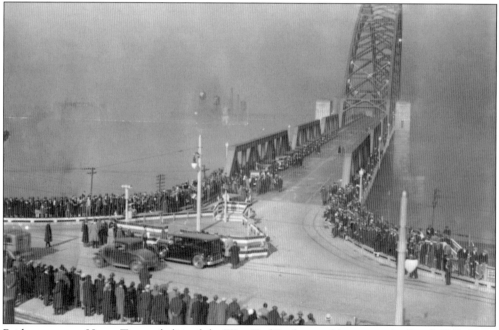

Bridge promoter Henry Tranter believed the West End Bridge would connect the South Hills, West End, and North Side in a marriage of prosperity. On December 2, 1932, Tranter's granddaughter Mary Hershberger cut the ribbon to open the bridge. The prosperity was slow to materialize due to the onset of the Great Depression. Eventually, the West End Bridge became one of Pittsburgh's busiest bridges. (Carnegie Library of Pittsburgh.)

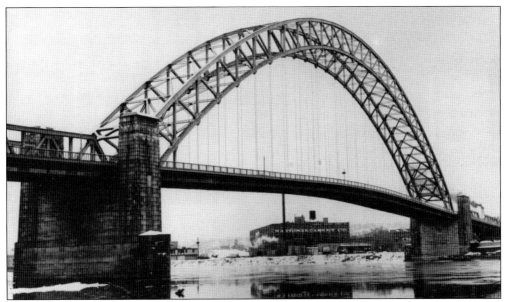

The West End Bridge was a marvel of engineering. With a 778-foot main span, the arch was 240 feet longer than the comparable 1929 Tacony-Palmyra Bridge in Philadelphia, the only other long-span, tied-arch bridge in America at that time. The West End Bridge was one of the first to use high-strength silicon steel. The deck was suspended with a novel method of prestressed wire rope hangers. (HDR Inc.)

The West End Bridge underwent rehabilitation in 1991. The bridge originally had truss spans on each end of the arch span. The truss spans on the north end (pictured) were demolished to permit construction of an interchange with Route 65. While the bridge is no longer symmetrical, the project provided a much-needed traffic improvement. (Library of Congress, Prints & Photographs Division, HAER PA,2-PITBU.V,3—31.)

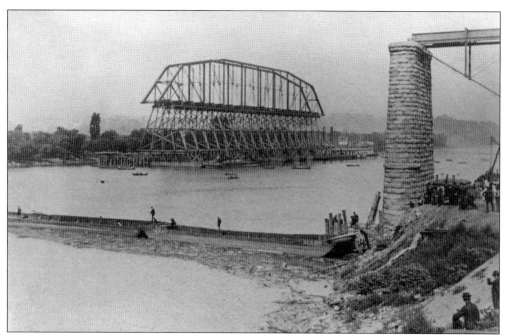

The Ohio Connecting Railroad Bridge over Brunot's Island was completed in 1890 as part of a Pennsylvania Railroad project to bypass Pittsburgh's congestion. Constructing a 523-foot main-channel span with 65-foot-tall trusses 75 feet above the river required an innovative solution, since the river had to remain open for commercial navigation. The river's main-channel span was built alongside Brunot's Island and floated into place on barges. (Carnegie Library of Pittsburgh.)

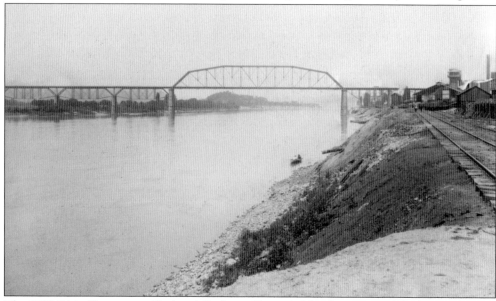

The 1890 Ohio Connecting Railroad Bridge at Brunot's Island was one of the longest bridges in America when it was built. It consisted of 29 spans, for a total length of over 4,500 feet. Seen here are the main-channel span and approach spans over Brunot's Island to the left. The photograph was taken before 1903, when a second approach was added to the bridge. (Carnegie Library of Pittsburgh.)

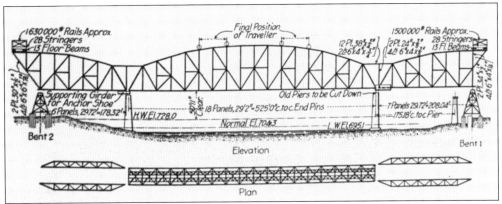

The Ohio Connecting Railroad began to consider replacing and widening the bridge over Brunot's Island in 1910, but high costs prevented it from being done until 1913. The railroad had to be operational during construction, and the river had to be free from obstructions. Engineers devised a plan for the back-channel span to be built in halves, placed to function as anchors, to allow balanced cantilevered construction of the main-channel span. This diagram is from the *Engineering Record*, Vol. 72, No. 3.

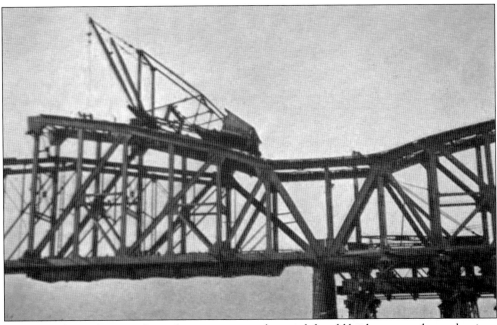

The main-channel span is shown being constructed around the old bridge outward over the river, free from supports (left), with half of the back-channel span providing the anchor (right). Once the main-channel span was completed, the back-channel halves were relocated and connected together. This construction method was possible because the new double-track bridge was wider than the single-track bridge it replaced. This illustration is from the *Engineering Record*, Vol. 72, No. 3.

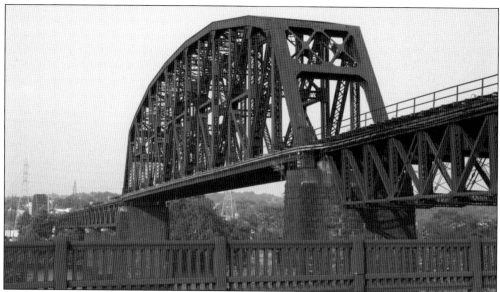

Pictured here is the back-channel span after its two sides were connected. The new, wider Ohio Connecting Railroad Bridge was opened to double-tracked rail traffic in 1915. The pin-connected deck truss approach span (far right) remains from a 1901 modification to the previous bridge, where a second approach track was added, merging onto the bridge. Wide enough for two-track operation, that particular span was not replaced.

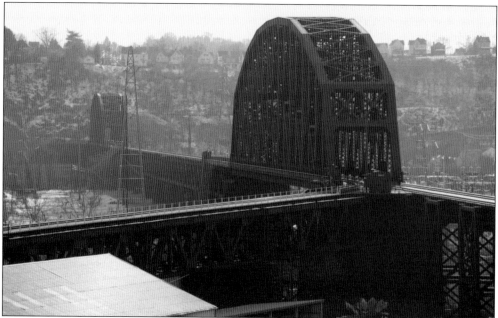

Through the early 1900s, large bridges were typically constructed with truss members pin-connected for ease of construction. Engineers were concerned that erecting the Ohio Connecting Railroad Bridge by cantilevering the back-channel span in halves and reerecting it would make pin connections unstable, since forces in the members were reversed during erection. Therefore, the truss members were riveted to connecting gusset plates. The bridge became America's longest-spanning bridge with rigid connections.

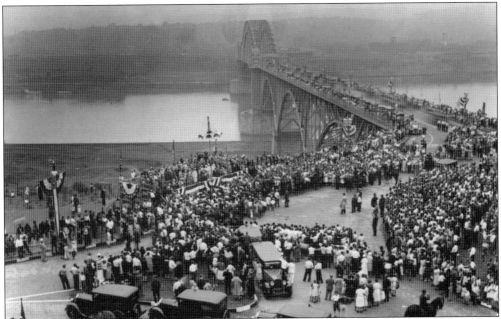

As Pittsburgh expanded westward along the Lincoln Highway, and McKees Rocks became an important manufacturing center, lack of transportation across the Ohio River became a concern. In the early 1900s, no vehicular bridges existed between Pittsburgh's Point and Sewickley, a distance of nearly 12 miles. After over two years of construction, the McKees Rocks Bridge was dedicated on August 19, 1931. The dedication ceremony included 2,000 cars. (Carnegie Library of Pittsburgh.)

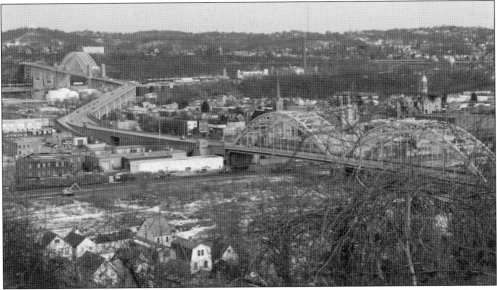

The total length of the McKees Rocks Bridge and approaches is 5,900 feet. It was one of the largest structures in the country when it was built. The main arch over the Ohio River (background) is 750 feet long. The smaller arches over the former Pittsburgh & Lake Erie Railroad shops in McKees Rocks (foreground) are European-style crescent arches, each 300 feet long. The deck trusses in between total 1,504 feet in length.

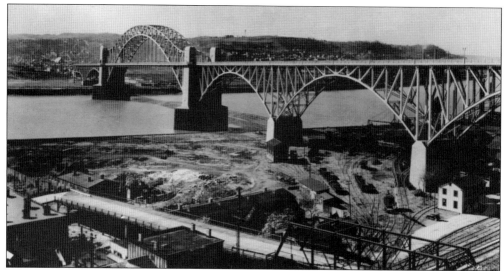

Planning for the McKees Rocks Bridge began in 1914, but the project stalled because the War Department required a prohibitive 1,100-foot main span. In 1928, plans for a McKees Rocks crossing were revived when the War Department relaxed span requirements and county commissioners approved a bond to construct major bridges and roads, including Ohio River Boulevard along the Ohio River's north shore. The bridge was incorporated into the boulevard's plan. (HDR Inc.)

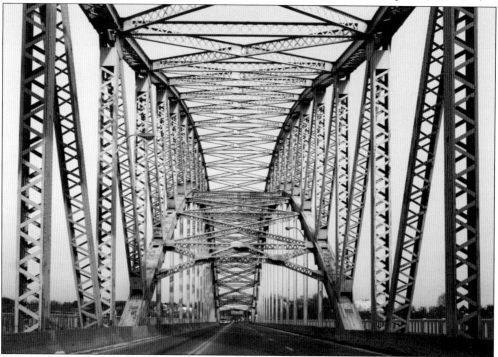

The McKees Rocks Bridge was not only the largest county-owned river bridge constructed at the time, but also, perhaps, the most monumental. Its design was said to pay tribute to New York City's 1916 Hell Gate Bridge, which was believed to be the largest bridge constructed by Carnegie Steel when built. The McKees Rocks Bridge's design is also similar to the Sydney Harbour Bridge, which opened seven months later.

Five
RAVINE BRIDGES

When the City of Pittsburgh was incorporated in 1816, it included just downtown. The city's first major bridges spanned only the Allegheny and Monongahela Rivers. Early development expanded beyond the city, especially in the flatlands along the rivers and in the wide East Liberty valley. If a road had to go over a hill, it followed the terrain up and down the slopes. As Pittsburgh's population grew in the 1800s, demand for residential and commercial space increased. The city annexed many of the surrounding communities, expanding onto hills that had previously been forest or farmland. Bridges were needed to connect these hilltop neighborhoods.

Electric trolleys came to Pittsburgh around 1886, opening up new areas for development. Trolleys required gentle slopes and curves, creating an unprecedented need for larger bridges over the city's ravines. The proliferation of automobiles in the early 1900s further increased the demand. Carriage roads were not designed to handle thousands of cars per day moving at faster speeds. Traffic congestion began to be an issue, and collisions became common on the narrow, winding roads.

A 1909 city planning report concluded that the lack of improved roads could inhibit Pittsburgh's growth. In 1910, two studies were commissioned to propose ways of easing traffic. Consultant Bion Arnold recommended building a downtown subway to reduce surface street congestion from trolleys. Renowned landscape architect and urban planner Frederick Law Olmsted Jr. concluded that higher-capacity automobile roads, or thoroughfares, were needed to efficiently connect downtown with city neighborhoods and suburbs. These thoroughfares could be cut along undeveloped hillsides and could be built across large ravines, serving city neighborhoods without destroying them. Pittsburgh bridged many valleys to implement parts of Olmsted's plan in the following years.

The need for efficient automobile routes extended beyond Pittsburgh. Allegheny County expanded its public works department in 1924 and created boulevards to facilitate commuter traffic into the city. The state's highway department designated state highways in 1911 and greatly enlarged its system in 1931. The state designed high-speed limited-access highways that opened starting in the 1950s. All these improved roads needed more bridges crossing ravines to conquer Pittsburgh's challenging topography.

This chapter highlights Pittsburgh's bridges over ravines and valleys, which allowed the city to conquer its terrain.

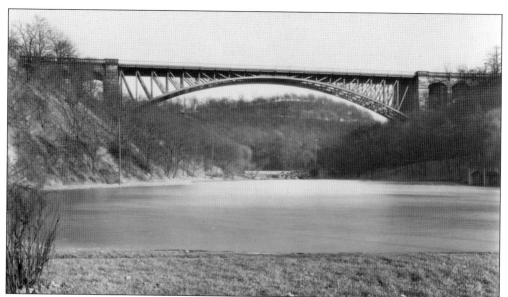

After a 20-year effort, the city obtained land from Mary Croghan Schenley for Schenley Park in 1889. Panther Hollow bisected the park, impeding access between Flagstaff Hill and Schenley Oval. The Panther Hollow Bridge was built across the valley, its arch providing an unobstructed view of the park below. The bridge was designed by the Pittsburgh Public Works Department and engineer Henry Rust. (Pittsburgh Department of Public Works.)

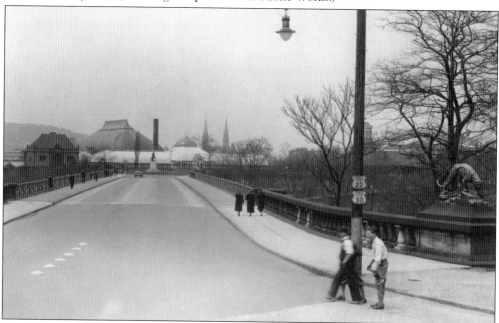

Director of Public Works Edward Bigelow wanted beautiful bridges in Schenley Park. Approximately half of the park's 1896 budget was allocated for that purpose. The Panther Hollow Bridge was constructed by Schultz Bridge & Iron Works from 1895 to 1896. Its deck was adorned with decorative railings. Giuseppe Moretti designed the panther sculptures. Original railings were replaced with Art Moderne wheat-bushel railings during rehabilitation in 1932. (Pittsburgh Department of Public Works.)

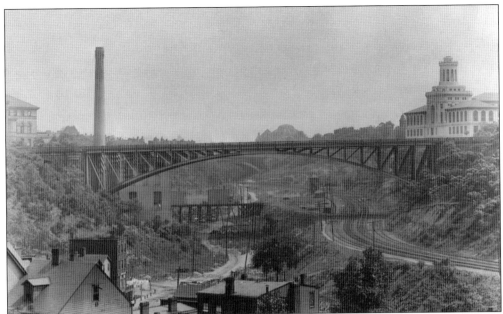

Schenley Park's first major bridge was a temporary 1890 wood-and-steel truss structure over Junction Hollow. By 1896, a museum, casino (arena), and conservatory had been built near each end of the bridge. The casino burned down in 1896, damaging the wooden bridge. It was replaced in 1897 by the steel arch Schenley Bridge, using the same design as the recently completed Panther Hollow Bridge. (Pittsburgh Department of Public Works.)

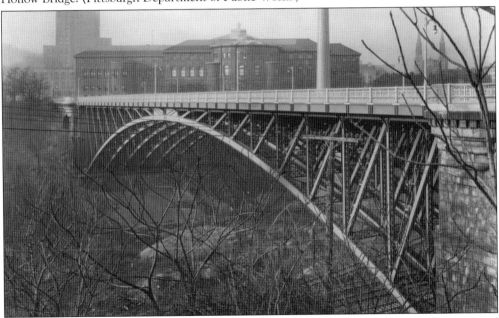

The 1897 Schenley Bridge was designed by the city and engineer Henry Rust and constructed by G.T. Richards. Like the Panther Hollow Bridge, its 360-foot, three-hinged steel arch span is flanked by stone arch approaches. The bridge had aesthetic dentils running its entire length beneath the deck, removed when the deck was replaced in a 1932 rehabilitation. Art Moderne wheat-bushel railings were installed. (Pittsburgh Department of Public Works.)

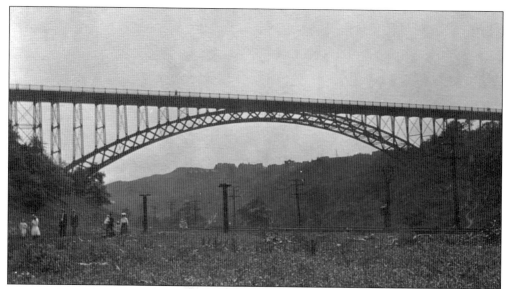

As Schenley Park was developed, the Wilmot Street Bridge was constructed in 1907 connecting Wilmot Street (Boulevard of the Allies) in South Oakland with Panther Hollow Road near the Panther Hollow Bridge and the park's former band shell. The arch bridge was built more for economy and less for aesthetics than the other park bridges. The Boulevard of the Allies was extended to the bridge in 1928. (Pittsburgh Department of Public Works.)

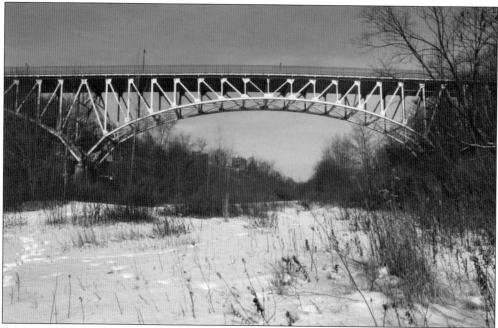

Unable to accommodate increased traffic from the Boulevard of the Allies, the two-lane Wilmot Street Bridge was replaced with the four-lane Charles Anderson Bridge in 1940, constructed by the Fort Pitt Bridge Works. The bridge was built with funding from the federal Public Works Administration. It has patented Wichert trusses, which are hinged diamond-shaped assemblies over the intermediate piers, allowing each span to flex independently. Fewer than 10 such bridges were ever constructed.

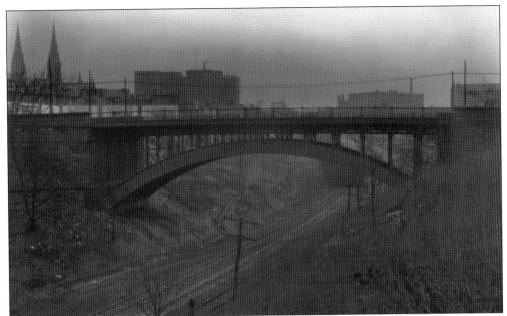

The first streetcar route to Squirrel Hill crossed Junction Hollow near the Schenley Bridge and cut through the present-day Carnegie Mellon University campus. The nearby Forbes Avenue Bridge over Junction Hollow was replaced in 1898 to carry the rerouted streetcar line. Designed by Pittsburgh's Public Works Department and engineer John Brunner, it was built by Stratton, Lewis & Co. It was replaced in 1983. (University of Pittsburgh/Archives Service Center.)

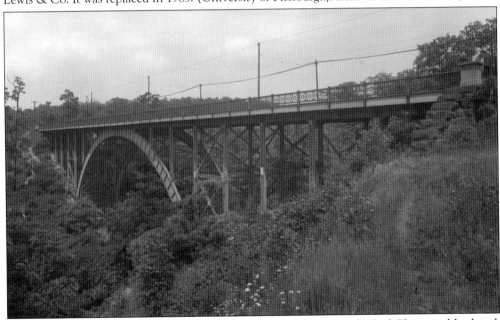

Forbes Avenue crossed Squirrel Hill to Braddock Avenue in Pittsburgh's Park Place neighborhood, originally winding down through Fern Hollow in what is now Frick Park. As part of streetcar upgrades, Schultz Bridge & Iron Works completed a three-hinged steel arch bridge over Fern Hollow in 1901, carrying a new alignment of Forbes Avenue over the valley. The bridge was replaced in 1972–1973. (University of Pittsburgh/Archives Service Center.)

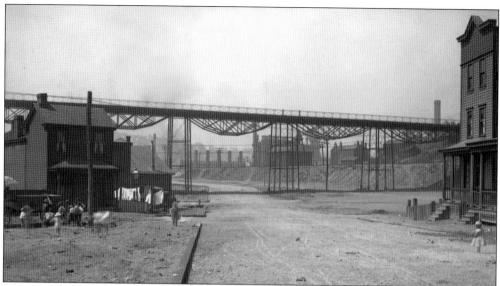

The Pittsburgh Junction Railroad was constructed through Four Mile Run valley (Lower Greenfield) in 1881–1883, when Oakland and Greenfield were developing. At the same time, Sylvan Avenue (Swinburne Street) was being constructed into the valley from Oakland, and Greenfield Avenue into the valley from Greenfield. The Sylvan Avenue Bridge, consisting of inverted bowstring truss spans, crossed the valley and railroad, connecting the avenues. (Archives Service Center/University of Pittsburgh.)

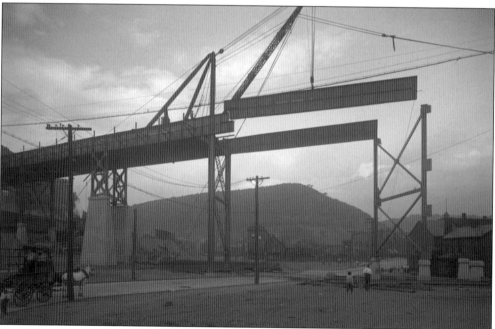

The Sylvan Avenue Bridge was replaced in 1914–1915 by the McClintic Marshall Company. The new bridge was designed to accommodate a proposed Baltimore & Ohio Railroad expansion that was never built. The proposed railroad embankment would have filled the area around the tall concrete pier (left). An early concept proposed a second upper-level bridge deck to directly connect Frazier and Bigelow Streets high above the valley. (Archives Service Center/University of Pittsburgh.)

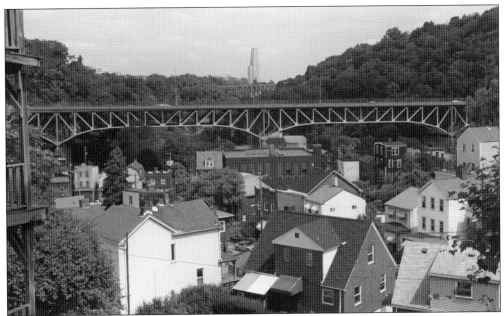

In 1939, famed New York urban planner Robert Moses presented a plan for the Penn-Lincoln Parkway, a high-speed expressway connecting downtown to the suburbs. The project was postponed until after World War II. The bridge at Frazier Street over Swinburne Street and Junction Hollow was constructed from 1949 to 1952 by B. Perini & Sons. The continuous deck truss bridge is 1,060 feet long, with two 264-foot main spans. It is the parkway's only truss bridge.

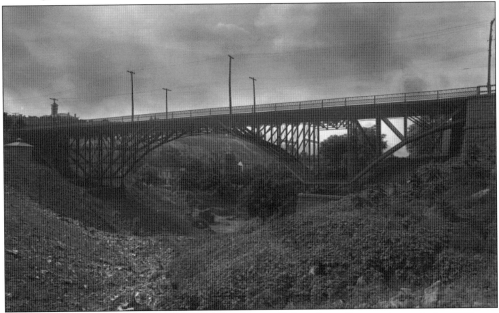

Cunliffe Hollow was a deep ravine in Oakland, parallel to Bates Street. Around the 1880s, an early deck cantilever bridge was constructed across the ravine, extending Wilmot Street to Halket Street. The ravine was filled in the early 1920s. The bridge's location is now the Boulevard of the Allies between Halket Street and Bates Street. The Boulevard of the Allies extension was completed in 1928. (Archives Service Center/University of Pittsburgh.)

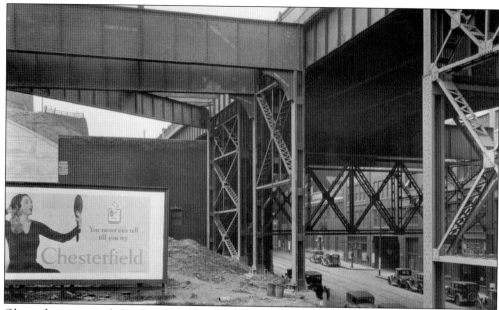

Olmsted recommended a thoroughfare connecting downtown with Greenfield and Hazelwood because Second Avenue, sandwiched between hillsides, railroads, and factories, could not be widened. The resulting Boulevard of the Allies was constructed from Second Avenue downtown along the bluff to Forbes Avenue in Oakland. It required a bridge over Second Avenue from downtown to the bluff. Ramps were added in 1931, as shown, connecting to the 1928 Liberty Bridge. (Pittsburgh Department of Public Works.)

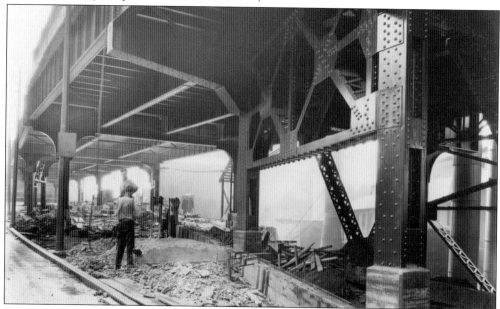

The original 1921 Boulevard of the Allies ended at an intersection with Forbes Avenue just east of a viaduct crossing a valley from Moultrie Street to Brady Street. To continue the boulevard toward Schenley Park, the intersection was removed and the viaduct extended over Forbes Avenue. The work is seen in this 1928 photograph. The viaduct was modified in the 1950s and integrated into the Parkway East interchange. (Pittsburgh Department of Public Works.)

Turning away from the hillside along the Monongahela River, Forbes Avenue entered Oakland along a now-filled ravine. The Boulevard of the Allies was extended over the ravine in 1928. This photograph shows the ramps from the boulevard to Forbes Avenue that created one of the first grade separations (interchanges) in Pittsburgh. The ravine was located where the ramp at right curves to meet Forbes Avenue. (Pittsburgh Department of Public Works.)

Lawn Street once connected directly to Forbes Avenue via this 1890s bridge over a ravine in Oakland. Not long after this 1921 photograph was taken, the ravine was filled, permitting construction of the Boulevard of the Allies interchange to Forbes Avenue (top image). The stone wall supporting Forbes Avenue (left) and the houses in the valley below indicate the size of the ravine that has vanished. (Pittsburgh Department of Public Works.)

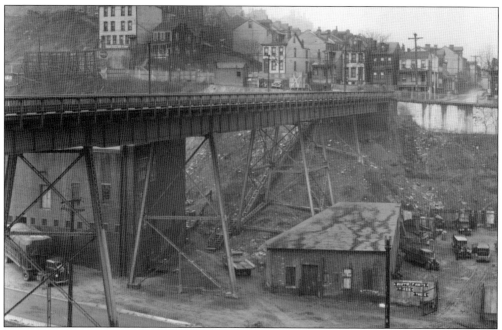

Around 1907, Mission Street was extended along the South Side Slopes, west from Sterling Street to South Eighteenth Street. This extension involved the construction of two bridges over ravines. The larger of the two bridges, located to the west toward South Eighteenth Street, crossed the South Twenty-first Street valley near the Pittsburgh Brewing Company Winter Brewery. It was a steel deck girder on trussed bents. (Pittsburgh Department of Public Works.)

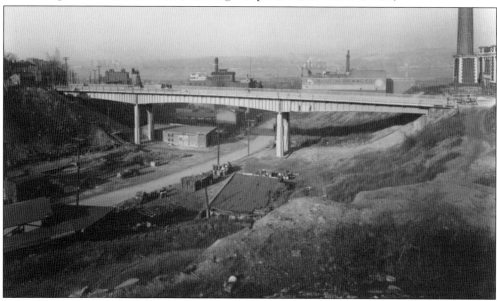

Funded by the Public Works Administration, part of federal Depression relief, the Mission Street bridges were replaced in 1939, including the 394-foot bridge over South Twenty-first Street (pictured). The bridges were early regional examples of continuous haunched girders. Haunched girders are deeper over the piers, providing more resistance to bending. The design is efficient for longer spans, such as this bridge's 160-foot main span. (Pittsburgh Department of Public Works.)

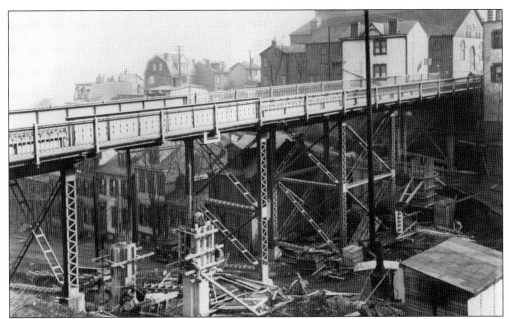

The first eastern Mission Street Bridge was constructed over the Greeley Street valley around 1907. It was a through girder design, with the girders supported by trussed bents. This February 1939 photograph shows the bridge when its replacement project was beginning. Note the concrete piers under construction for its replacement directly below the bridge. The piers were built before the old bridge was closed for demolition. (Pittsburgh Department of Public Works.)

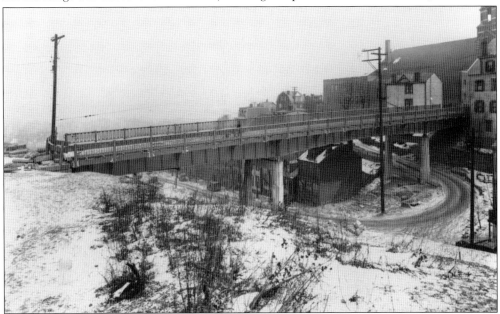

The new eastern Mission Street Bridge, shown nearing completion in February 1940, was funded by the Public Works Administration. It is also an early continuous haunched girder design. Shorter than the western bridge, the main span is 92 feet and the total length is 225 feet. Both were designed by the city and constructed by the Bethlehem Steel Company. They have Art Moderne–style railings and piers. (Pittsburgh Department of Public Works.)

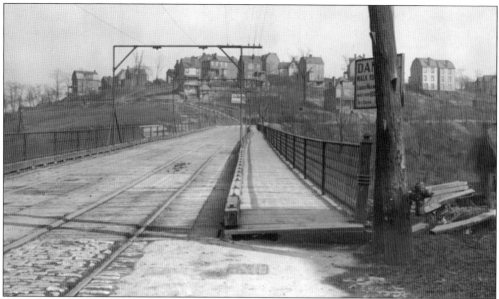

In Greenfield, the Magee Field valley was once deeper. In 1892, a bridge was built carrying Greenfield Avenue across the valley between Ronald and Monteiro Streets. The bridge closed in 1915 and was demolished. Instead of building a new bridge, Greenfield Avenue was rerouted to its current alignment along Wheatland Street between Ronald and McCaslin Streets. The former section of Greenfield Avenue became McCaslin Street. (Pittsburgh Department of Public Works.)

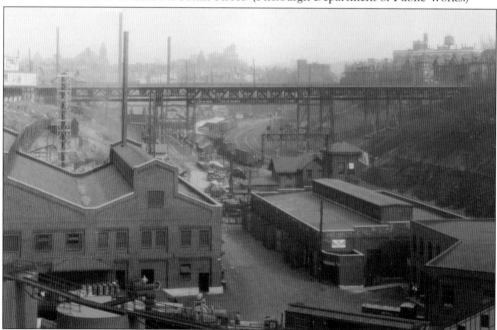

In Bloomfield, Millvale Avenue originally ran north from Centre Avenue to the Pennsylvania Railroad's Millvale Station in Two Mile Run valley. In 1893–1894, a streetcar line was routed along Millvale Avenue, and a bridge was constructed over the valley. Millvale Avenue was extended along Fitch Street to connect to Liberty Avenue. Typical of streetcar bridges, the structure was a rigid Warren-deck truss on trussed bents. (Pittsburgh Department of Public Works.)

The Millvale Avenue Bridge was replaced in 1927–1928. The steel girders were fabricated off-site and brought to the construction site for erection. This December 1927 photograph shows steel girders fabricated for the new bridge in the yard of the Independent Bridge Company on Neville Island. The girders were shipped to the site for erection once the support towers were completed. (Pittsburgh Department of Public Works.)

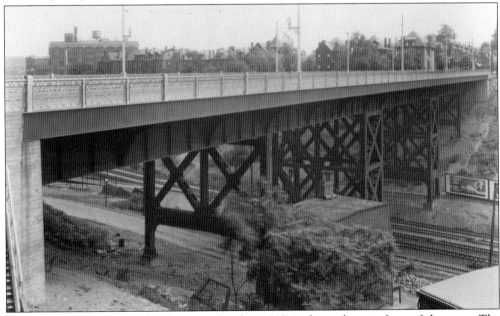

The new Millvale Avenue Bridge, completed in 1928, is shown here in June of that year. The bridge consists of alternating 87-foot and 65-foot spans, supported on 22-foot trussed steel bents. Architect Stanley Roush's design included eagle sculptures forming the base of the light poles (now removed) and steel railings with a reticulated pattern. The railings were restored in the bridge's 2007 rehabilitation. (Pittsburgh Department of Public Works.)

An 1872 ordinance authorized the Pennsylvania Railroad to construct a bridge on South Aiken Avenue over Two Mile Run valley in present-day Shadyside. The bridge had a pin-connected Pratt deck truss main span with three lines of trusses. The approaches consisted of deck girders supported on trussed bents. This photograph was taken in November 1928, just before work started on replacing the bridge. (Pittsburgh Department of Public Works.)

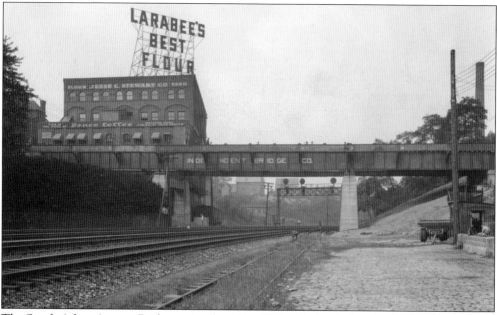

The South Aiken Avenue Bridge was replaced in 1929 with the deck girder bridge shown under construction in August 1929. Like the nearby 1928 Millvale Avenue Bridge, the girders were fabricated by the Independent Bridge Company on Neville Island. The span was closed in 1978, and the girders were replaced in 1979. The concrete piers were reused for the new bridge. (Pittsburgh Department of Public Works.)

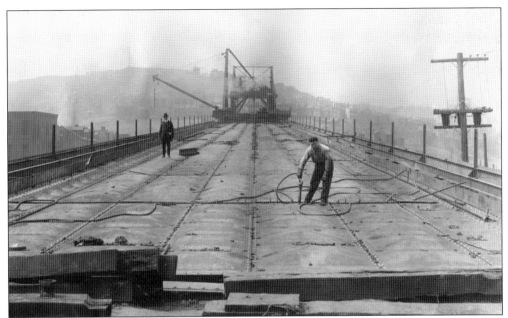

Opening in 1900, Grant (now Bigelow) Boulevard was constructed along the southern face of Bedford Hill, across Two Mile Run valley from Bloomfield. Residents lobbied the city for 12 years for a bridge. The Fort Pitt Bridge Works won the contract in December 1913. Here, a worker pauses for a photograph while riveting the bridge's flooring on the Bloomfield end in May 1914. (Pittsburgh Department of Public Works.)

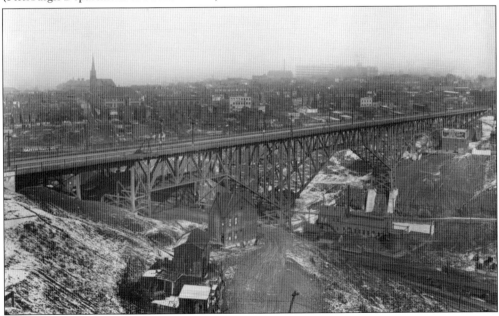

Upon completion in November 1914, the Bloomfield Bridge was the largest and highest ravine crossing designed by the city. The 2,100-foot truss bridge was cantilevered to avoid piers in the valley's deepest part. The bridge had two cantilever arms, each 140 feet long, projected outward to support a 120-foot suspended span, forming a 400-foot main span. The bridge was closed to traffic in 1978, demolished in 1980, and replaced in 1984. (Carnegie Library of Pittsburgh.)

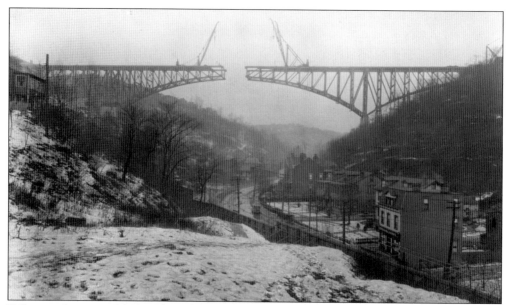

Following the successful 1914 Bloomfield Bridge, Pittsburgh planned to erect a larger cantilever-truss bridge carrying Charles Street over the East Street valley. Since the Perry Hilltop neighborhood was developing rapidly along Perrysville Avenue, a bridge was conceived to spur development to the east. Construction finally began in early 1929. This December 1929 photograph shows the superstructure approaching completion, the sides nearly joined above the valley. (Pittsburgh Department of Public Works.)

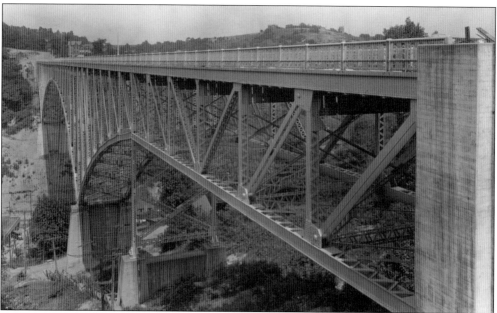

The 225-foot-high bridge, constructed by the Fort Pitt Bridge Works, was named for prominent industrialist E.H. Swindell. It opened in September 1930 and is shown here in January 1931. The 1,097-foot bridge has a 545-foot main span. Unlike the structurally similar 1914 Bloomfield Bridge, the smooth bottom curve indicates that aesthetics influenced the bridge's design. The valley was cleared in the 1980s for Interstate 279. (Pittsburgh Department of Public Works.)

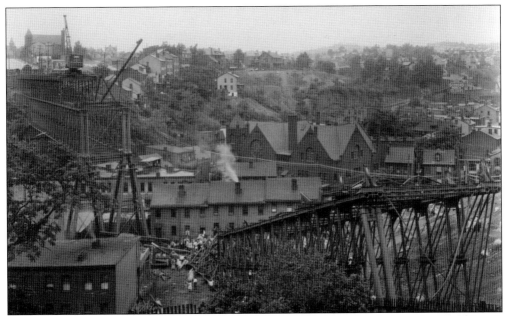

The Pennsylvania Railroad wanted to control the narrow strip of land along the Ohio River's north bank. In exchange, it helped Allegheny City route California Avenue along the top of the bluffs. The railroad moved its 1862 Ohio River bridge from Steubenville to carry California Avenue over Woods Run valley in 1889. The deck was raised 17 feet in 1896. The bridge's 1926 demolition is seen here. (Pittsburgh Department of Public Works.)

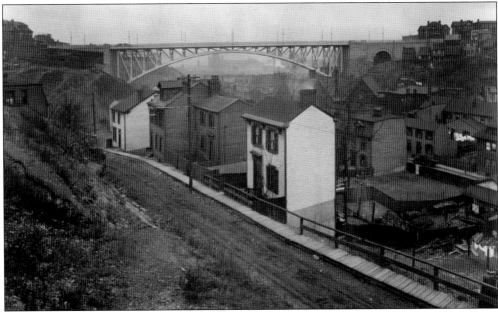

The California Avenue Bridge was replaced in 1927 with a steel arch bridge similar in appearance to the Schenley and Panther Hollow bridges. Constructed 30 years later, the bridge had only two arch ribs. The steel approaches were hidden by faux concrete arches (since removed), dressed to resemble the stone Schenley Park bridge approaches. The crossing was named after Robert McAfee, Allegheny City's public works director. (Pittsburgh Department of Public Works.)

In 1904, Shady Avenue was extended over the Woods Run Valley on a 775-foot viaduct consisting of 10 girder spans supported by trussed bents. The bridge, built by the American Bridge Company, was 110 feet high, with spans up to 74 feet in length. After Allegheny City was annexed by Pittsburgh, Shady Avenue became Shadeland Avenue. The bridge was rehabilitated in 1930, demolished in 1991, and replaced by a new bridge in 1993.

Allegheny City began to develop Riverview Park in 1894 and Davis Avenue in 1896. The Woods Run valley limited access from the west, so a bridge was constructed in 1898–1899. It was a pin-connected deck cantilever designed by Gustave Kaufman and constructed by the Fort Pitt Bridge Works. The bridge was 396 feet long, with a 156-foot main span. After an unsuccessful 1986 rehabilitation, the bridge was removed in 2009.

Six
CITY BEAUTIFUL BRIDGES

The rapid expansion of cities in the 1800s, spurred by industrialization and immigration, created an unrelenting demand for new bridges carrying streets, railroads, and trolley lines. Economics dictated the form of the bridges. Aesthetics were typically limited to minor embellishments on otherwise functional structures. This began to change in the late 1800s as cities began developing parks and paying more attention to beautifying the urban environment. Landscape architects trying to make bridges harmonious with their environment began to consider a bridge's structure as part of its architecture.

The 1893 World's Columbian Exposition in Chicago helped solidify urban planning ideals of the time. Exposition buildings, designed in the neoclassical Beaux-Arts style, provided a vision for what cities could be—an orderly environment emphasizing dignity, the necessity of order, and harmony for all classes. This vision, which became known as the City Beautiful movement, was further promoted in the 1904 Louisiana Purchase Exposition in St. Louis.

Simultaneously, concrete began to be used as a bridge-building material. America's first concrete bridge was erected in 1871, and the first to be reinforced with steel was constructed in 1889. Concrete became widely used in the early 1900s, even before engineers fully understood its properties. It was cheaper than stone and thought to be more durable than wood or metal. A perceived drawback was that bare concrete was considered unsightly. Since concrete could be finished to look like stone and formed into any shape, architects were called upon to beautify concrete bridges. In 1911, Pittsburgh formed its Municipal Art Commission to review and approve the architecture of proposed civic structures, including bridges. They became canvases for embellishment, with neoclassical details to express the vision of the City Beautiful movement.

The Pittsburgh Department of Public Works constructed eight major concrete-arch bridges between 1909 and 1928 under civic architect Stanley Roush. This chapter focuses on these city-designed bridges, as well as the stone bridges that inspired them. The city's bridges subsequently inspired Allegheny County and state-designed bridges up through the 1950s.

The 1898 Bellefield Bridge was constructed over St. Pierre's Ravine in Schenley Park, replacing a bridge damaged when the nearby multipurpose Casino arena burned down in 1896. It was the city's first large masonry-arch bridge, approximately 150 feet long, 100 feet high, and 80 feet wide. The ravine was filled from 1912 to 1915, and the Mary Schenley Memorial Fountain was built atop the buried bridge. (Carnegie Library of Pittsburgh.)

Under director Edward Bigelow, Schenley Park was developed by park superintendant William Falconer (1896–1903) and his successor, George Burke (1903–1926). Early work included shaping the land and constructing roads and trails. Pittsburgh's first two concrete arch bridges were constructed for the bridle path in 1908. The bridge near Bartlett Street is shown here. The concrete was faced with tufa, a porous limestone, creating a rustic look. (Collection of Michael Ehrmann.)

The Pennsylvania Railroad constructed its Brilliant Branch above present-day Washington Boulevard in the Negley Run valley in 1903. The railroad's stone-arch viaduct over Silver Lake conflicted with the city's intersecting Lincoln Avenue Bridge, which had to be demolished and temporarily replaced with a footbridge. A 1904 ordinance authorized the city to pay the railroad to complete the intersecting Lincoln Avenue stone arch bridge in 1905. (Pittsburgh Department of Public Works.)

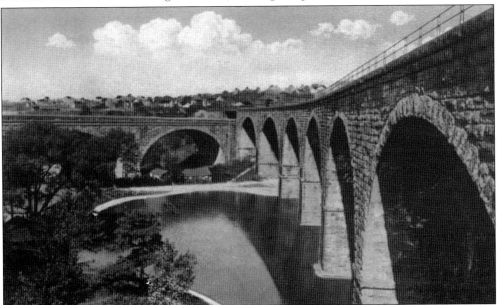

The Lincoln Avenue Bridge (left) has two spans, each 130 feet long. It was Pittsburgh's last major stone arch bridge built for roadway traffic. The photograph shows Silver Lake, a popular recreational spot, between the Lincoln Avenue (left) and Pennsylvania Railroad (right) bridges. The lake was to be incorporated into Highland Park, but instead was filled in and became the site of a drive-in theater and, later, a carwash and industrial area. (Pittsburgh History & Landmarks Foundation.)

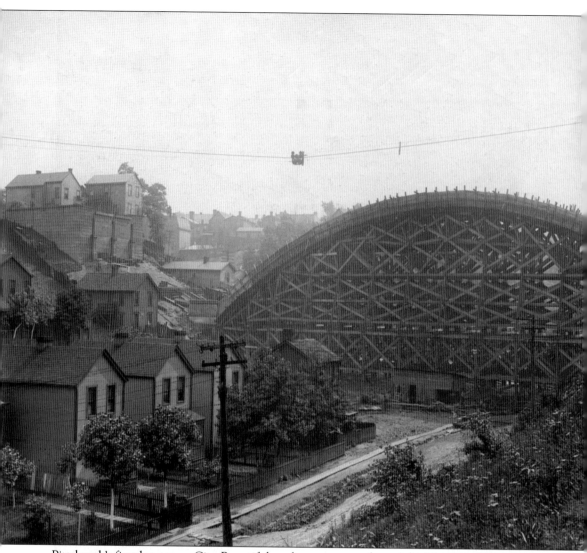

Pittsburgh's first long-span City Beautiful–style concrete arch was the Meadow Street Bridge between Larimer and East Liberty. Early concrete bridges were constructed like stone bridges. A temporary curved wooden support structure called centering was used to support the arch under construction. Concrete was cast into forms attached to the centering, which was removed when the concrete had sufficiently set. This June 1910 photograph shows construction of the Meadow Street Bridge's arch. The homes in Negley Run valley were demolished when the valley was incorporated into Highland Park. The bridge was inspired by Philadelphia's 1908 Walnut Lane Bridge in Fairmount Park, which pioneered long-span concrete arch bridge building in America. Philadelphia decided to construct a concrete arch because city planners believed the design would be ideal for a beautiful and economical bridge in a parklike setting and would not disrupt the valley below with supports. Looking to construct a bridge of similar size in a valley planned for a park, Pittsburgh built the Meadow Street Bridge two years later. The main arch is 24 feet shorter than Philadelphia's bridge. (Pittsburgh Department of Public Works.)

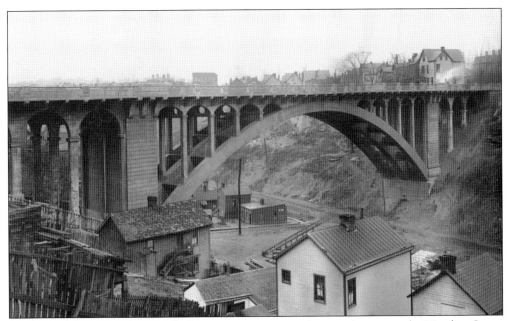

This November 1910 photograph shows construction work wrapping up on the Meadow Street Bridge, which became an excellent example of architecture blended with functionality. The success of the Meadow Street Bridge set the Pittsburgh Department of Public Work's agenda for the construction of several similar concrete bridges, including six within the next four years. (Pittsburgh Department of Public Works.)

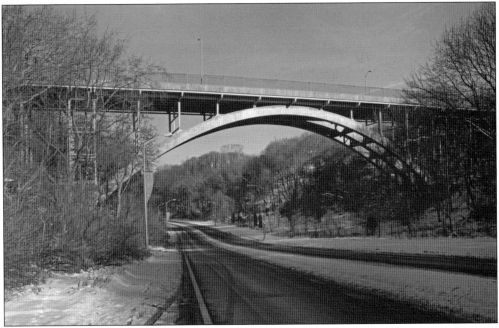

By the 1920s, it had become evident that concrete was not a maintenance-free material, as was previously believed. Cracks began to form in the spandrel columns above the Meadow Street Bridge's concrete arch within a few years. In 1962, most of the bridge was demolished except for the arch itself. A new steel deck was built on top of the original arch.

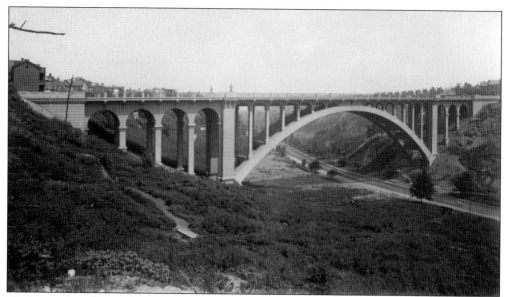

Work started on the nearby Larimer Avenue Bridge in 1911, shortly after the Meadow Street Bridge was completed. The Larimer Avenue Bridge replaced an 1892 wood-and-metal bridge that could not carry streetcars. The new bridge had a 300-foot span, reportedly the second-longest-spanning concrete arch in the world at the time of completion. The bridge opened in August 1912 and is seen here in 1913. (Pittsburgh Department of Public Works.)

The Larimer Avenue Bridge was built when Joseph Armstrong was mayor. A plaque, a bronze tablet designed by Stanley Roush, was placed beneath the bridge. The land was to be incorporated into Highland Park, including a landscaped trail to a monument that was never developed. Armstrong became Allegheny County commissioner in 1924, promising to construct roads and bridges. His 1928 campaign posters appear beside the plaque that bears his name. (Pittsburgh Department of Public Works.)

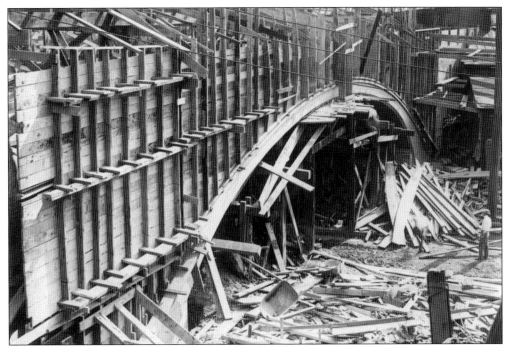

The last concrete bridge constructed in Negley Run valley carried Hoeveler Street (East Liberty Boulevard) over Everett Street (Princeton Place). It is shown here in September 1912. The bridge was replaced in 1968 when East Liberty Boulevard was created by realigning and widening preexisting streets. Everett Street, now abandoned, was once the main route from East Liberty to Washington Boulevard. (Pittsburgh Department of Public Works.)

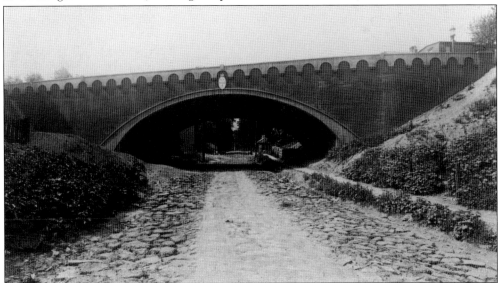

The completed Hoeveler Street Bridge crossing Everett Street (Princeton Place) is shown in June 1913. The bridge illustrates an attempt to create an aesthetic effect not just with form but also with color, since the bridge's concrete spandrel walls were dyed a darker color to contrast with the lighter arch ring and parapets. The seal of Pittsburgh was placed above the arch's crown. (Pittsburgh Department of Public Works.)

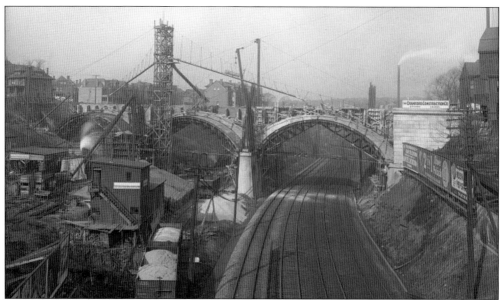

Penn Avenue, the main route from East Liberty to downtown, became overwhelmed with traffic in the early 1900s. Taking advantage of less-developed, rougher terrain, Pittsburgh constructed Atherton Avenue (Baum Boulevard), linking East Liberty to the recently completed Grant (Bigelow) Boulevard. Its bridge over the Pennsylvania Railroad is shown under construction in October 1912. Steel centering from Blaw Steel (Blaw-Knox Company) was used to minimize obstructions below. (Archives Service Center/University of Pittsburgh.)

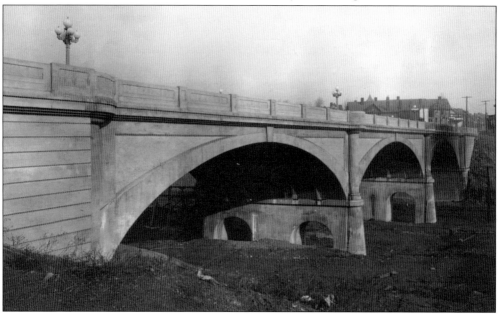

The Atherton Avenue (Baum Boulevard) Bridge over the Pennsylvania Railroad was completed in 1913. Instead of one large arch, the bridge consisted of three smaller 98-foot closed-spandrel arches, a better fit for the shallow valley. The bridge included decorative lampposts and concrete parapets with incised bush-hammered panels. Spandrel walls were recessed, and arch rings and keystones were accented. The bridge lasted until 1985. (Pittsburgh Department of Public Works.)

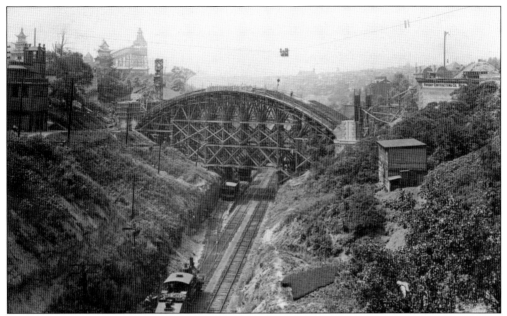

As Atherton Avenue (Baum Boulevard) approached Craig Street, a bridge was built over the ravine carrying the Pittsburgh Junction Railroad near Neville Street. This June 1912 photograph shows wooden centering in place for the arch being erected by the Friday Construction Company. Luna Park, an amusement park once located at the intersection of Baum Boulevard and Craig Street, is visible in the background. (Pittsburgh Department of Public Works.)

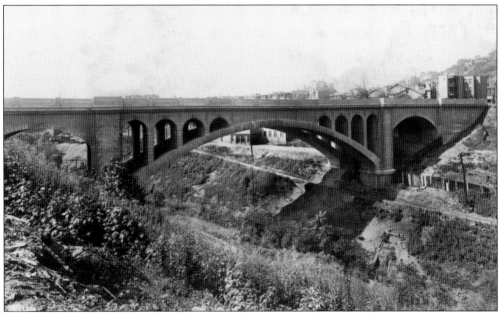

The Atherton Avenue (Baum Boulevard) Bridge over the Pittsburgh Junction Railroad was completed in 1913 and is seen here in July of that year. The bridge's striking architectural features included paneled parapets and concrete textured to look like stone. The bridge lasted until 1973, when the arches were demolished due to deterioration. The piers were reused to support a new steel-beam bridge. (Pittsburgh Department of Public Works.)

In the 1890s, an electric-trolley line was constructed by the Schenley Park, Highland & Homestead Railway (later Pittsburgh Railways) to connect Oakland and Homestead. The route through Squirrel Hill and Greenfield required the construction of the steel deck truss bridge shown here in 1913. The bridge was typical of trolley crossings. It was located where the Murray Avenue Bridge now stands. (Pittsburgh Department of Public Works.)

In the 1890s, Squirrel Hill and Greenfield were mostly undeveloped, so the trolley line did not follow existing streets. Right-of-way was reserved along the new line for an extension of Murray Avenue, which was under construction in 1913. The original Murray Avenue Bridge accommodated trolleys only. No carriages, vehicles, or pedestrians were permitted. (Pittsburgh Department of Public Works.)

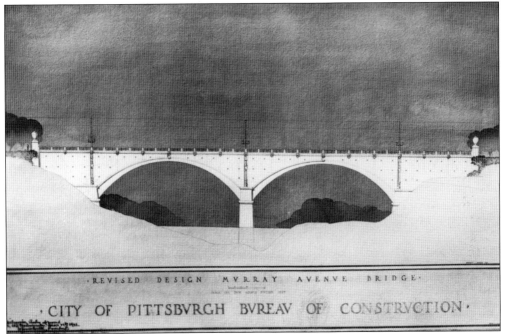

In November 1912, two concepts were presented to replace the Murray Avenue trolley bridge with an ornate concrete arch bridge. Design A presented a two-span concrete arch bridge with solid spandrel walls. Part of the valley below would be filled in. The proposed bridge's architecture appears to be similar to the recently constructed Hoeveler Street Bridge and Atherton Avenue Bridge over the Pennsylvania Railroad. (Pittsburgh Department of Public Works.)

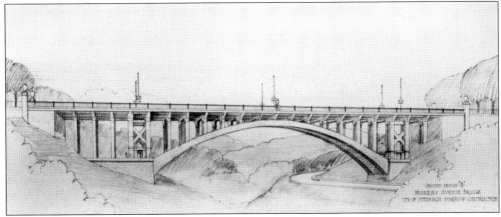

Design B for the new Murray Avenue Bridge presented an open-spandrel concrete arch similar to the Meadow Street and Larimer Avenue bridges. This design would preserve the valley floor below. Design B was the option ultimately chosen. Even the proposed decorative urns on each end and the eagle sculpture above the handrail in the center, shown in the proposed drawing, were constructed. (Pittsburgh Department of Public Works.)

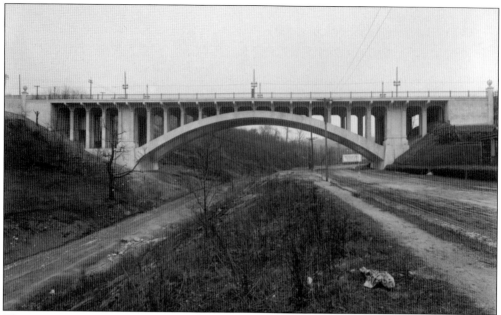

The Murray Avenue Bridge was completed in 1914. It is shown here in 1915, looking southeast from around Forward Avenue. The bridge crossed over Beechwood Boulevard (right) and Saline Street (left), now part of the Parkway East (I-376) interchange. The decorative urns on each side of the bridge and the eagle sculptures above the handrail in the center are visible. (Pittsburgh Department of Public Works.)

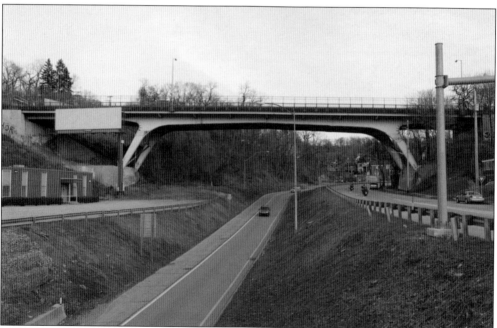

In 1978, the Murray Avenue Bridge was demolished and replaced by a steel frame girder bridge of similar proportions. The handrails and urns are gone, but the eagle sculptures in the center of the old bridge were saved and relocated to guard the entrance to the city's asphalt plant at the intersection of Washington and Allegheny River Boulevards.

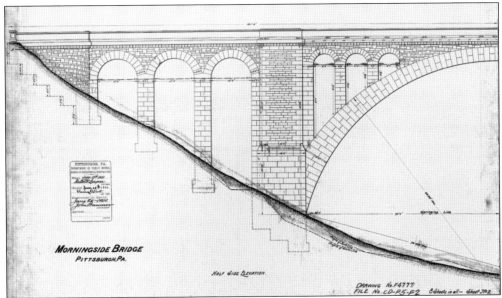

Pittsburgh's first large parks, Schenley and Highland, were established in 1889. A sweeping boulevard, originally called Beechwood Avenue, was planned to connect the parks starting at a bridge over Heth's Run at Highland Park and ending at a bridge over Four Mile Run at Schenley Park. This Heth's Run Bridge concept from 1900 presented an ornate open-spandrel stone arch design, comparable to state-of-the-art European bridges. (Pittsburgh Department of Public Works.)

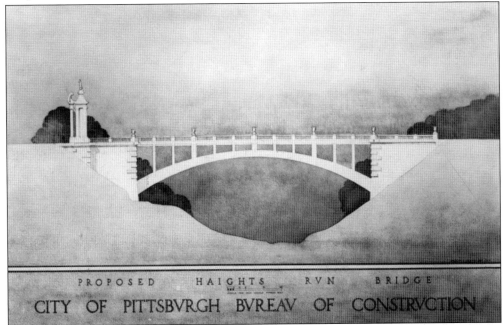

Construction of Heth's Run Bridge was delayed, and the design was changed. This December 1912 illustration shows the final concept—a concrete arch to be ornamented by neoclassical balustrades and urns. The gateway monuments to the left of the bridge appear to be similar to Highland Park's existing gateway monuments at the Highland Avenue entrance. Only the bases of the monuments were constructed on the bridge. (Pittsburgh Department of Public Works.)

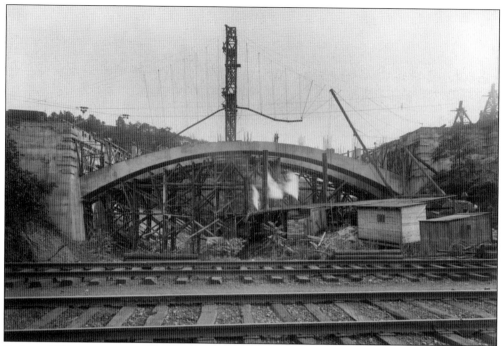

By June 1914, construction of the Heth's Run Bridge was well under way. The abutments and concrete arch ribs had been completed. Work was beginning on the columns that would connect the arch with the road deck. This view looks south from the adjacent railroad tracks toward the present-day Pittsburgh Zoo. (Pittsburgh Department of Public Works.)

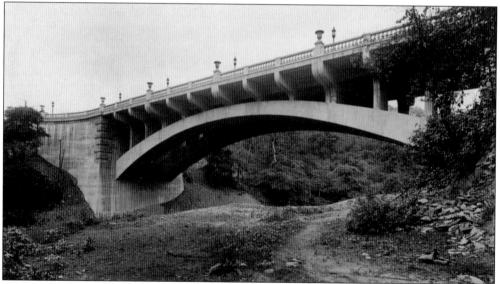

The 1914 Heth's Run Bridge (pictured) had ornamental balustrades, urns, lampposts, and false quoins to create a grand entrance to Highland Park. The valley was later filled, becoming the zoo's parking lot, and motorists no longer noticed the bridge was still there. PennDOT and Buchart Horn Inc. designed the bridge's award-winning 2014 replacement, reestablishing the bridge's original vision by replicating its architectural features and daylighting the valley below. (Pittsburgh Department of Public Works.)

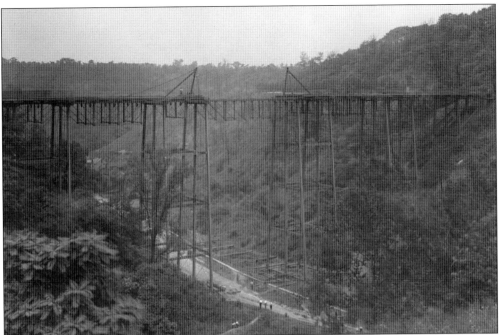

A bridge at the opposite end of Beechwood Boulevard was needed to cross Four Mile Run valley (now Parkway East, I-376) into Schenley Park. The first bridge was a hastily built wood-and-steel structure, shown here under construction in June 1909. The city hoped to replace it with a grand concrete arch bridge similar to Heth's Run Bridge when funding became available. (Pittsburgh Department of Public Works.)

This 1911 photograph shows the completed Beechwood Boulevard Bridge. At the time, Beechwood Boulevard was also known as William Pitt Boulevard. City Beautiful bridges were responses to bridges like this one, built for function, not for appearance. This view looks west along Saline Street, also known as Forward Avenue, which was covered over when the Parkway East (I-376) was constructed in the 1950s. (Pittsburgh Department of Public Works.)

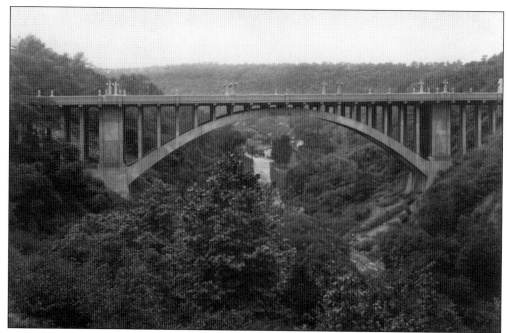

In the early 1920s, a neoclassical concrete arch bridge was built to replace the previous Beechwood Boulevard Bridge. Its main span was 279 feet, nearly the length of the Larimer Avenue Bridge. The Beechwood Boulevard Bridge, also known as the Greenfield Bridge, was completed in 1923, giving Schenley Park its southern grand entrance envisioned years before. This photograph dates from 1929. (Pittsburgh Department of Public Works.)

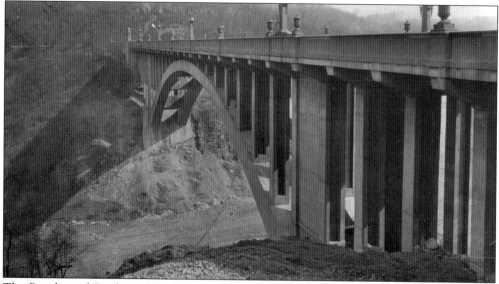

The Beechwood Boulevard Bridge was adorned with embellishments designed by architect Stanley Roush, including Indiana limestone urns and pylons, lampposts with decorative bronze lamp holders, and bush-hammered concrete parapets. The bridge's 1980 rehabilitation removed most of this ornamentation. The structure will be replaced from 2015 to 2017 with a metal arch bridge replicating or reusing the previous bridge's ornamentation, restoring the grand Schenley Park entrance. (Pittsburgh Department of Public Works.)

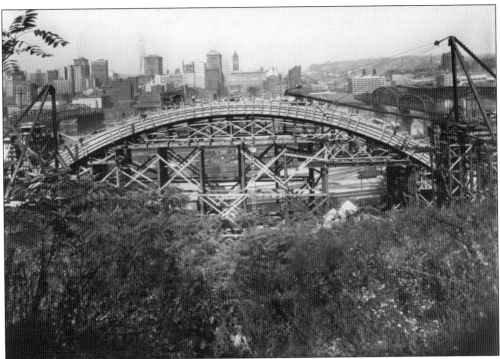

Envisioned since 1910, the Mount Washington (P.J. McArdle) Roadway was constructed in 1927–1928, connecting the Liberty Bridge and Tunnels with Grandview Avenue. It required construction of a bridge over Sycamore Street and the Castle Shannon Incline (closed in 1964) in the ravine below. This September 1927 photograph shows the wooden centering and falsework in place, with the concrete arch ribs ready to be cast. (Pittsburgh Department of Public Works.)

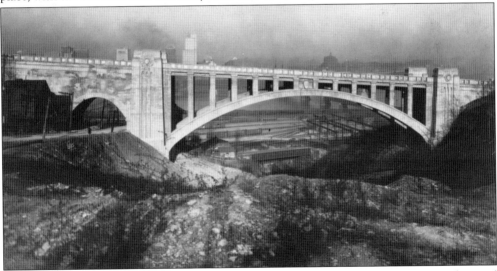

The 1928 Mount Washington (P.J. McArdle) Roadway Bridge was the last large city-designed concrete arch bridge and one of architect Stanley Roush's most ornate designs. The bridge was adorned with decorative pylons surrounded by friezes and balustrades fitted with Pittsburgh's shield. The spandrel columns connecting the road deck and arch were fluted and filleted to resemble Doric columns. The bridge was replaced in 1983. (Pittsburgh Department of Public Works.)

107

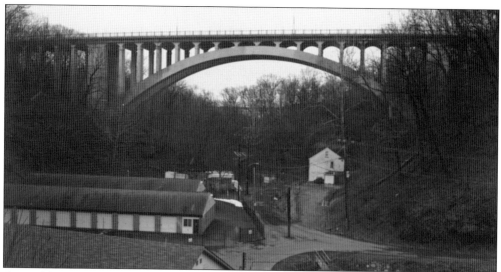

Around 1890, California Avenue was constructed from Allegheny City (Brighton Heights) to Belleview, above Jacks Run valley. In 1922, the John Eichleay Jr. Company slid the previous bridge 175 feet from its former location, keeping it open while its replacement was constructed. Allegheny County hired former city engineer Norman Sprague as design consultant for its first large concrete arch, spanning 320 feet. The bridge was rehabilitated in 1967 and 2011.

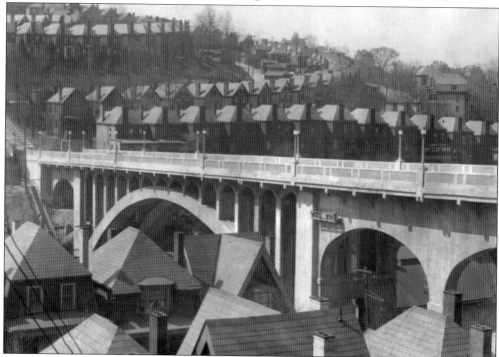

The Allegheny County Department of Public Works' second large concrete arch bridge was the John P. Moore Memorial Bridge in Knoxville. It replaced the previous structure carrying Georgia Avenue between Rochelle and Arabella Streets over the Bausman Street ravine. The photograph shows the bridge just before its opening in May 1928. It carried traffic until 1975 and was demolished in 1978. Only the abutments remain. (Carnegie Library of Pittsburgh.)

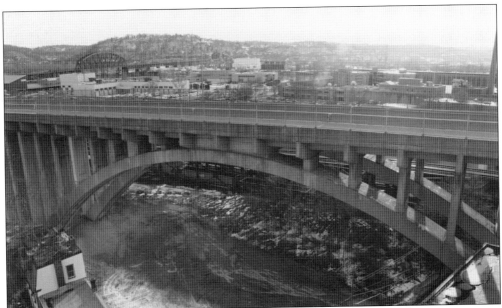

In 1924, the new Allegheny County Department of Public Works presented its planned Ultimate Highway System, consisting of riverside boulevards, radial highways, and circuit routes. Ohio River Boulevard was the most challenging to construct, running along undeveloped hillsides on bluffs overlooking the Ohio River. The route required six large concrete arch bridges. The easternmost bridge was the 510-foot structure over Woods Run, which had a 270-foot arch. It was completed in 1930.

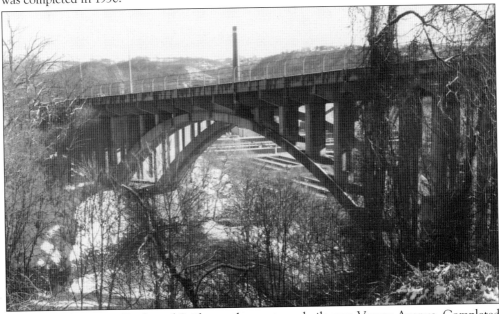

The next Ohio River Boulevard Bridge to the west was built over Verner Avenue. Completed in 1930, the 390-foot bridge has a 210-foot span. It was constructed around the same time as the 1931 McKees Rocks Bridge. The two bridges once intersected at a now-removed traffic circle. Verner Avenue ran beneath both bridges to Verner, a small neighborhood along the Ohio River removed in the 1950s.

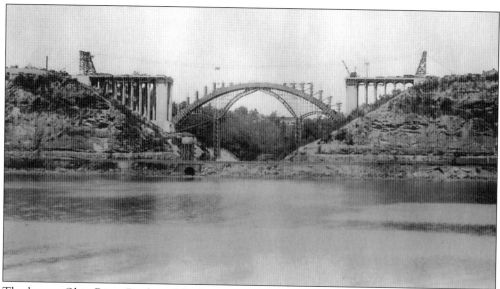

The largest Ohio River Boulevard bridge spanned Jacks Run valley, between Brighton Heights and Belleview. Shown under construction in September 1930, the 720-foot bridge's 420-foot concrete arch was briefly America's longest, eclipsed by the George Westinghouse Bridge's 460-foot arch in 1932. The Jacks Run Bridge was abruptly closed due to deterioration in June 1983, demolished in September of that year, and replaced in 1984. (Allegheny County Department of Public Works.)

Pittsburgh's last large concrete arch bridge was built from 1948 to 1951. Designed by the Pennsylvania Department of Highways, it carries the Parkway East (I-376) over Nine Mile Run valley in Frick Park, east of the Squirrel Hill Tunnel. As the International style became prevalent after the World War II, bridges were not often adorned. This bridge, however, has transverse Gothic arches beneath the deck and vertically scored pilasters at the piers.

Seven
Railroad Overpasses

Pittsburgh's railroad age began in the early 1850s. The Pennsylvania Railroad, first known as the Central Railroad, was constructed in Pittsburgh in 1851 and completed to Philadelphia in 1854. The line entered present-day Pittsburgh city limits from Wilkinsburg, following low terrain along the East Liberty valley and the Allegheny River to Pittsburgh.

The Ohio & Pennsylvania Railroad entered the city along the Ohio River in 1851. It became the Pennsylvania Railroad's Fort Wayne Division. Other important railroads included the Pittsburgh & Lake Erie; Western Pennsylvania; Pittsburgh, Cincinnati, Chicago & St. Louis (Panhandle Division); Pittsburgh & Connellsville (Baltimore & Ohio); and Wabash. The first railroads were typically constructed at street level, since trains were infrequent and speeds were slow. As the urban environment developed and trains became faster, longer, and more frequent, the potential for conflicts increased wherever roads and railroads intersected. Meanwhile, railroads wanting to widen their lines began to encroach on adjacent roads and buildings.

By the 1870s, the city and railroads began to work together to promote expansion while minimizing conflicts. Roads and railroads were realigned and raised or lowered to avoid at-grade crossings. This required constructing overpasses, also called overhead bridges. In many cases, roads were built over railroads, since carriages and, later, automobiles could more easily traverse steeper slopes approaching overhead bridges.

In 1872, Pittsburgh and the Pennsylvania Railroad compromised on how best to improve the busy main line through the city. Pittsburgh agreed to vacate streets along the railroad in the Shadyside, Bloomfield, and East Liberty neighborhoods, and the railroad agreed to construct bridges to eliminate at-grade crossings. Overhead bridges would be built at Ellsworth Avenue, Shady Avenue, South Aiken Avenue, Roup Street (Negley Avenue), and Thirty-third Street (Herron Avenue), and the existing Penn Avenue and Centre Avenue bridges would be reconstructed. This allowed the Pennsylvania Railroad to be widened from two tracks to four.

In the years that followed, more overhead bridges were constructed and modified to meet the needs of the railroads. This chapter explores many of the bridges built to cross the railroads that were an essential part of Pittsburgh's rise to industrial prominence.

Ellsworth Avenue originally extended straight beyond Spahr Street in Shadyside to the intersection of Highland and Centre Avenues in East Liberty. Around 1880, Wilson Brothers & Company designed a 190-foot skewed cast iron and wrought iron Whipple truss with ornate vertical members to cross over the Pennsylvania Railroad. Replacement of the bridge began in 1908 (pictured), with the new bridge constructed around the old one. (Pittsburgh Department of Public Works.)

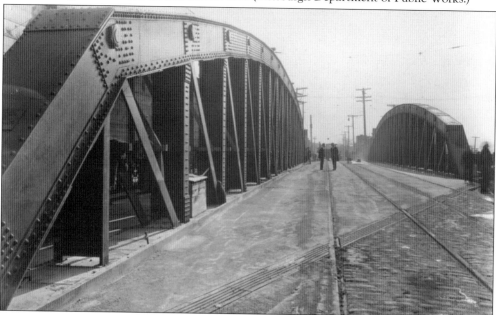

The second Ellsworth Avenue Bridge was completed in 1908 over the Pennsylvania Railroad. Constructed by the McClintic-Marshall Company of Pittsburgh, it was an unusually tall example of a skewed pin-connected Parker pony truss with ornate railings. The bridge, along with the adjoining Spahr Street footbridge, was demolished in 1978 for East Busway construction underneath. Ellsworth Avenue was rerouted and extended to Shady Avenue. (Pittsburgh Department of Public Works.)

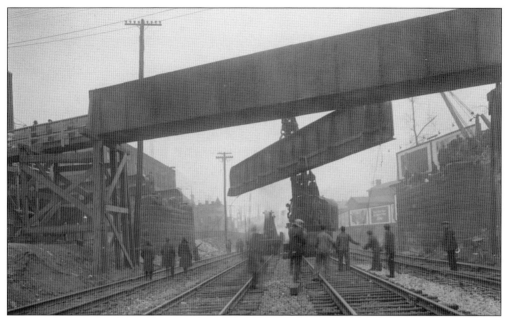

The first bridge over the Pennsylvania Railroad at Highland Avenue between Shadyside and East Liberty was designed by Wilson Brothers & Company. The iron through girder was constructed in 1878 and was demolished in 1925. Here, the last girder over the railroad is being removed in March of that year. A temporary footbridge above the tracks maintained pedestrian traffic during construction. (Pittsburgh Department of Public Works.)

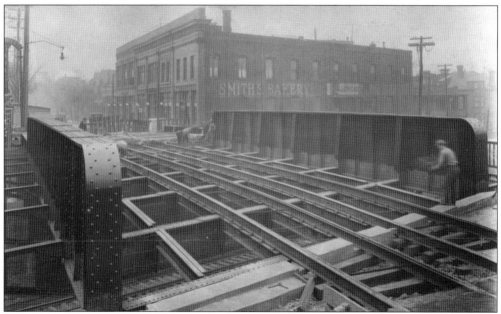

The second Highland Avenue Bridge was completed in 1925. This April 1925 photograph, taken six weeks after the previous photograph, shows that the new steel superstructure had been quickly erected. The through girder bridge was constructed by the Fort Pitt Bridge Works. It had a 76-foot span over the Pennsylvania Railroad and a 41-foot side span over Ravenna Street (Ellsworth Avenue). The superstructure lasted until 2013. (Pittsburgh Department of Public Works.)

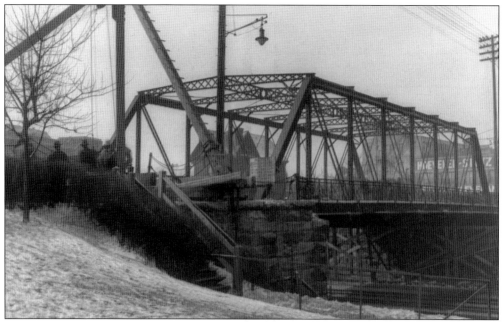

The first Negley Avenue (formerly Roup Street) Bridge over the Pennsylvania Railroad was constructed in the 1880s as part of a project to improve and widen the railroad from two tracks to four. It was an example of a pin-connected Pratt through truss with a main span of 106 feet. This February 1924 photograph shows work underway to replace the bridge. (Pittsburgh Department of Public Works.)

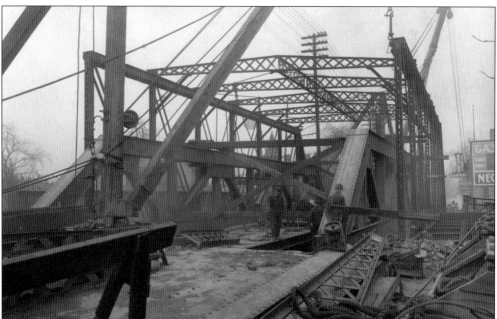

This March 1924 photograph shows the American Bridge Company constructing the new Negley Avenue Bridge inside the previous span. This method of erection allowed the old bridge to be used as falsework. It minimized disruption to road traffic and to rail traffic below. The replacement bridge is a 106-foot Warren pony truss. (Pittsburgh Department of Public Works.)

Herman Haupt was an important Pennsylvania Railroad engineer in the early 1850s, when the railroad was constructed across Pennsylvania. He worked on developing an all-metal bridge design—a cast iron arch tied by iron trusses. The railroad built such bridges from 1851 to 1861, replacing them as trains became heavier. Many were recycled for overhead roadway crossings, like the Centre Avenue Bridge (pictured), built around 1872. (Pittsburgh Department of Public Works.)

The new Centre Avenue Bridge is seen here in May 1922. The concrete-encased steel girder bridge was constructed on the piers of the previous iron Haupt truss bridge. Concrete encasement was used on steel bridges to eliminate painting and to improve the steel's resistance to damage from the heat and smoke from steam engines. The bridge was replaced in 1978 for the East Busway project. (Pittsburgh Department of Public Works.)

An 1884 ordinance permitted construction of a bridge near Thirty-third Street at Forfar Street (now Herron Avenue) for Pennsylvania Railroad expansion and Pittsburgh Junction Railroad construction. It had deck girder approach spans and a deck truss main span. When the Pittsburgh Junction Railroad had to be raised to accommodate a higher Allegheny River bridge, a Warren pony truss replaced the deck truss in 1916 (pictured). (Pittsburgh Department of Public Works.)

An ordinance for the Twenty-eighth Street Bridge over the Pennsylvania Railroad was approved in 1879, and the bridge was completed in 1880. The cast iron and wrought iron bridge was a double intersection Warren pin-connected through truss, embellished with decorative railings and cast iron decorative end caps. The bridge crossed the railroad near the Twenty-eighth Street Engine House. (Pittsburgh Department of Public Works.)

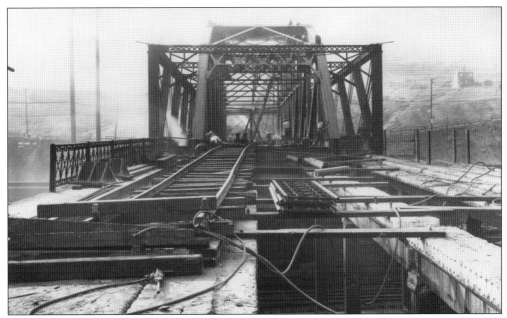

The first Twenty-eighth Street Bridge closed for replacement in July 1930. The new bridge was constructed within the previous bridge, as shown here in July 1931. This erection method used the old bridge for support, allowing construction of the new bridge to take place without disrupting Pennsylvania Railroad operations below. The masonry piers from the previous bridge were reused. (Pittsburgh Department of Public Works.)

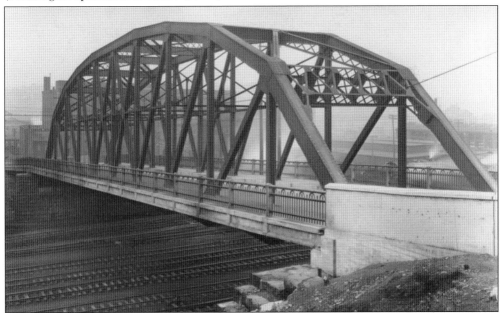

The second Twenty-eighth Street Bridge over the Pennsylvania Railroad was completed in 1931. It is an example of a Parker through truss, spanning 202 feet over the railroad below. The bridge, seen here in January 1932, is 315 feet long, including approaches. The bridge deck was encased with concrete to protect the steel from the exhaust of steam locomotives below. (Pittsburgh Department of Public Works.)

In the 1880s, Jones & Laughlin constructed coke ovens in Hazelwood, and the Baltimore & Ohio Railroad built car shops in Glenwood. A residential area developed between them, connected to Second Avenue by a bridge over the B&O tracks at Elizabeth Street. The Parker pony truss was rehabilitated in 1914 (pictured), with a steel deck surfaced by wood-block pavers. (Pittsburgh Department of Public Works.)

The Elizabeth Street Bridge's original main span, crossing over the Baltimore & Ohio Railroad in Hazelwood, was replaced in 1925 with a Warren pony truss, shown here in 1926. The remaining approach spans were replaced in 1931. The second Elizabeth Street Bridge was closed to traffic in March 1978. It was replaced with a steel beam bridge that opened in 1979. (Pittsburgh Department of Public Works.)

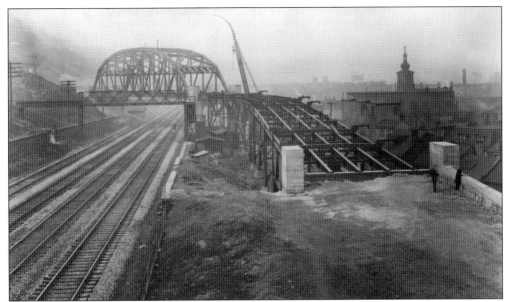

Noting its difficulty and expense, Frederick Law Olmsted's 1910 report recommended improving access to Mount Washington with a gently sloping roadway along the hillside. The upper Mount Washington (McArdle) Roadway from Grandview Avenue to Brownsville (Arlington) Avenue opened in 1928. The lower roadway to Tenth Street opened in 1933 and included Viaduct No. 1 over the Pennsylvania Railroad, shown under construction in January 1933. (Pittsburgh Department of Public Works.)

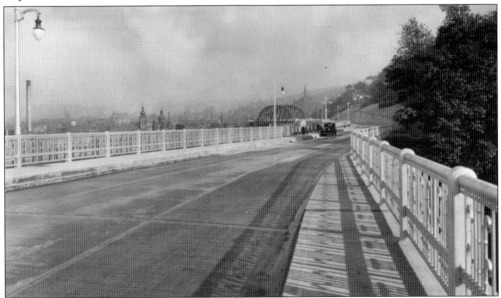

Lower Mount Washington Roadway opened between Brownsville (Arlington) Avenue and Tenth Street in September 1933. This October 1933 photograph shows the completed Viaduct No. 1, a 215-foot Parker through truss over the Pennsylvania Railroad, in the background. Viaduct No. 2, which carried the roadway over the hillside near Brownsville (Arlington) Avenue, is in the foreground. The roadway was renamed for its advocate, Councilman P.J. McArdle. (Pittsburgh Department of Public Works.)

In 1901, the Pittsburgh, Fort Wayne & Chicago Railway (later the Fort Wayne Division of the Pennsylvania Railroad) and Allegheny City agreed to eliminate all at-grade crossings. The railroad was responsible for depressing its line through Allegheny Commons and replacing the Ohio Street and Ridge Avenue bridges. In 1903, the Fort Pitt Bridge Works constructed new Warren pony truss bridges. The Ohio Street Bridge is pictured here.

The Pittsburgh, Fort Wayne & Chicago Railway (Pennsylvania Railroad Fort Wayne Division), found it particularly troublesome to eliminate the grade crossing at the North Avenue and Irwin Avenue (Brighton Road) intersection. To comply with the 1901 agreement, the railroad was lowered, the roadways were raised five feet, and perpendicular through girder bridges were built. Seen here in 1926, they were replaced with a single structure in 1929. (Pittsburgh Department of Public Works.)

Eliminating an at-grade intersection, Y-shaped bridges were constructed over the Pittsburgh, Fort Wayne & Chicago Railway (Pennsylvania Railroad Fort Wayne Division) connecting perpendicular Washington (Columbus) and Allegheny Avenues to California Avenue. Construction began in 1905, was halted by strike, and finished in 1910 with wood-block paving (pictured). Allegheny Avenue's half (foreground) was closed in 1970 and demolished. Columbus Avenue's half (background) was rehabilitated in 1990. (Pittsburgh Department of Public Works.)

In the 1880s, a bridge was constructed over the Pittsburgh, Fort Wayne & Chicago Railway (Pennsylvania Railroad Fort Wayne Division) connecting Marshall Avenue with Chartiers Street (Chateau Street) in Manchester. Andrew Carnegie's Keystone Bridge Company fabricated the Pratt truss bridge's patented tubular column compression members. It was replaced in 1910 with a through girder, which was replaced by the Route 65 interchange around 1972. (Pittsburgh Department of Public Works.)

The Pittsburgh, Cincinnati, Chicago & St. Louis Railroad (later Pennsylvania Railroad's Panhandle Division) was constructed through Pittsburgh's present-day Sheraden neighborhood around 1863. Chartiers Avenue was realigned to carry streetcars over the railroad in 1886. The Corliss Bridge was replaced in 1908 and again in 1939 with a concrete-encased steel beam bridge (pictured), paid for by the railroad, streetcar company, and Works Progress Administration. (Pittsburgh Department of Public Works.)

Castor Street was once located along the side of Chicken Hill (Green Tree Hill), connecting Independence Road (Greentree Road) with Adolph Street in Pittsburgh's Ridgemont neighborhood. Completion of the Wabash Terminal Railroad in 1904 necessitated Castor Street's realignment, and a wooden Howe pony truss was built over the tracks. Pittsburgh abandoned Castor Street when Independence Road was widened in 1930. The bridge was later demolished. (Pittsburgh Department of Public Works.)

Eight

FOOTBRIDGES

In early American cities, workers lived within walking distance of their places of employment. Mass transit in the form of trains and horse-drawn streetcars came to Pittsburgh in the 1850s. Other forms of transit followed, including inclines and electric trolleys in the late 1800s. Mass transit allowed residential development to spread out from the growing factories that increasingly consumed the land along the valleys and floodplains. The city expanded along transit lines, because workers could walk to transit stops to commute to their places of employment. Without much flat land, Pittsburgh often developed upwards, with houses built along the hills nearest to the factories or transit stops. Pedestrian routes, often staircases, were constructed in challenging terrain where roads could not be built. Footbridges were erected to connect to staircases or to provide shortcuts across streams or valleys to transit stops.

The city's earliest roads and railroads were often constructed along the valleys. Locating roads and railroads at the base of hillsides reduced the chances they would be disrupted by flooding, while leaving the floodplains open for development. Roads and railroads increasingly began to encroach on one another in the late 1800s and early 1900s, as unpaved carriage roads and single-track railroads were widened to multilane highways and multitrack railroads, carrying thousands of vehicles and hundreds of trains per day. Some residential areas became isolated if a new railroad was constructed, or an existing railroad was widened and the main street was moved from one side of the tracks to the other. Inexpensive footbridges were constructed to reconnect those older communities.

This chapter provides a look at a few of the pedestrian bridges crossing ravines, streams, roads, and railroads in Pittsburgh. As automobiles became prevalent in the 20th century, most of the city's footbridges became disused and were later removed, though a few have been recently rebuilt.

A saltworks was established in the early 1800s where Nine Mile Run flows into the Monongahela River. The area, now called Duck Hollow, developed after Brown's Bridge was built across the Monongahela River in 1897. Around 1915, residents petitioned the city for a footbridge from McFarren Avenue (MacFarren Street) to cross Nine Mile Run to Brown's Bridge. This photograph dates from 1919, when the bridge was new. (Pittsburgh Department of Public Works.)

This May 1936 photograph shows the reconstructed MacFarren Street footbridge without the truss seen in the previous photograph. Presumably, the bridge was rebuilt after Pittsburgh's devastating March 1936 St. Patrick's Day Flood, which destroyed the deck of the nearby Second Avenue (MacFarren Street) Bridge over Nine Mile Run. Brown's Bridge over the Monongahela River is in the background. (Pittsburgh Department of Public Works.)

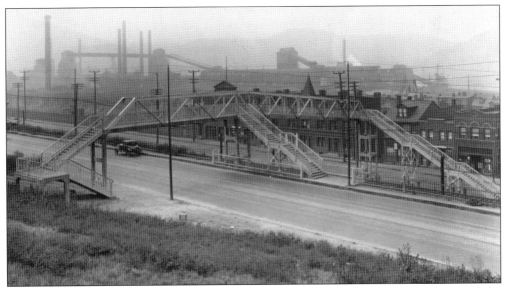

Rutherglen Street was a residential street in Hazelwood between Second Avenue and the Monongahela River, isolated by Jones & Laughlin steel mills. The 1929–1931 Irvine Street Program eliminated Hazelwood's dangerous Second Avenue railroad crossing by raising the Baltimore & Ohio tracks eight feet and shifting Second Avenue traffic to Irvine Street between Greenfield and Hazelwood Avenues. The Rutherglen Street Footbridge was constructed in 1930 to maintain neighborhood access. (Pittsburgh Department of Public Works.)

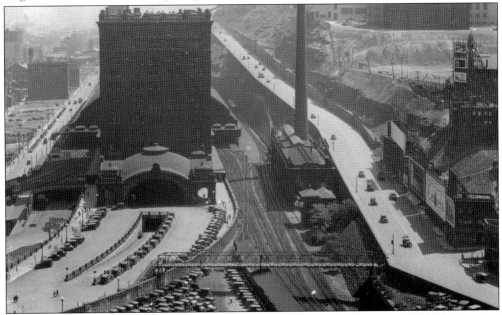

The 1898 project to construct Penn (Union) Station included a double intersection Warren truss footbridge (bottom center) from the intersection of Bigelow Boulevard and Washington Street (Washington Place) in the busy Hill District, across the tracks to the train station downtown. A pedestrian tunnel was later constructed under Bigelow Boulevard connecting to the footbridge. The bridge was demolished around 1960 for the construction of Crosstown Boulevard. (Pittsburgh Department of Public Works.)

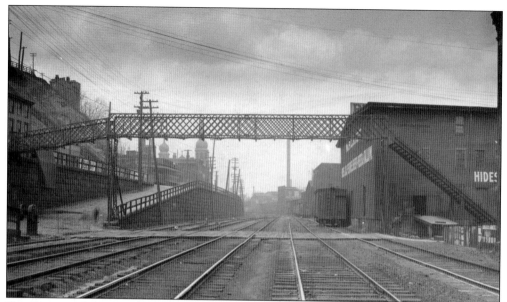

Pine Street ran between Ohio Street, now Route 28, and the Allegheny River, serving a residential area between the Heinz Company and Allegheny City's waterworks. The 1890s lattice girder bridge (pictured) crossed the Western Pennsylvania Railroad. It was replaced by a concrete structure around 1910, which was demolished a decade later to accommodate road and rail expansion. St. Nicholas Church can be seen in the background. (Pittsburgh Department of Public Works.)

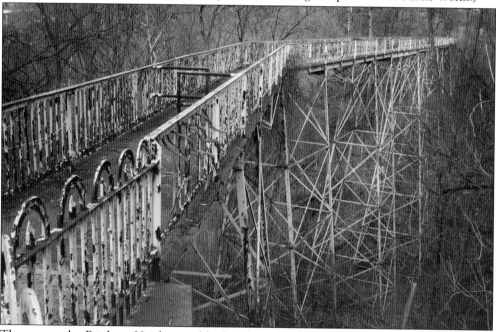

The present-day Brighton Heights neighborhood was developed in the 1890s along Termon and California Avenues. Only California Avenue had trolley lines, so a footbridge was constructed along Wheeler (now Wilksboro) Avenue to provide pedestrian access. The 1890s bridge is about 407 feet long and about 120 feet high. It was closed to pedestrians in 2007. The tall bridge consists of king post and queen post truss-stiffened steel beams supported on trussed bents.

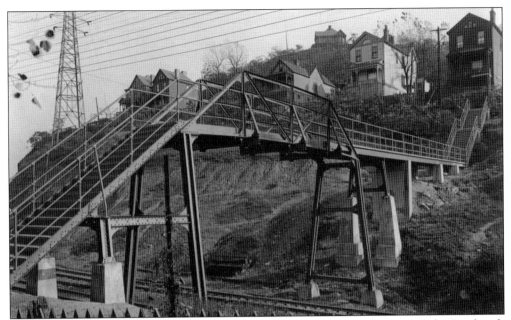

In 1901, the Ohio Connecting Railroad was constructed through what is now the Pittsburgh neighborhood of Esplen, so a pedestrian bridge at Orchard Street (Oregon Street) was needed across the railroad. The Oregon Street footbridge was reconstructed in 1919. It is seen here in November of that year. It had a Pratt pony truss over the tracks. The bridge was removed sometime around 1960. (Pittsburgh Department of Public Works.)

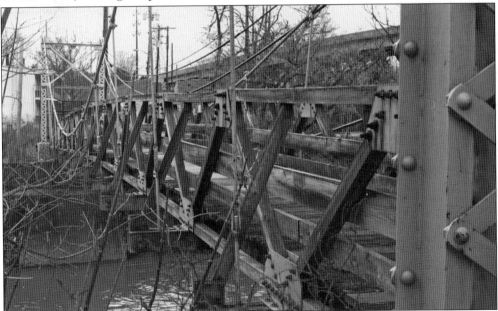

Railroads were constructed along both sides of Chartiers Creek, impacting travel on Windgap Avenue, which had a bridge from Pittsburgh to McKees Rocks Borough. Windgap Avenue was realigned in 1915 with a new, longer bridge crossing both railroads and the creek. A suspension footbridge was built as a pedestrian shortcut where the original bridge once stood. Damaged by Hurricane Ivan floodwaters in 2004, the bridge was demolished in 2007.

Discover Thousands of Local History Books Featuring Millions of Vintage Images

Arcadia Publishing, the leading local history publisher in the United States, is committed to making history accessible and meaningful through publishing books that celebrate and preserve the heritage of America's people and places.

Find more books like this at
www.arcadiapublishing.com

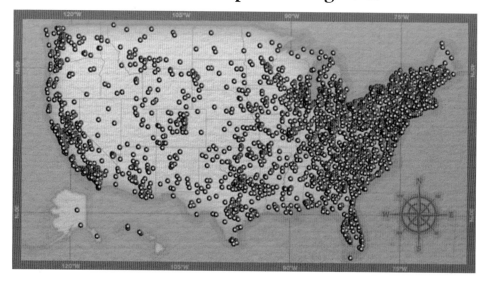

Search for your hometown history, your old stomping grounds, and even your favorite sports team.

Consistent with our mission to preserve history on a local level, this book was printed in South Carolina on American-made paper and manufactured entirely in the United States. Products carrying the accredited Forest Stewardship Council (FSC) label are printed on 100 percent FSC-certified paper.